the VOGUE book of **blondes**

VIKING
STUDIO

In praise of Oscar and in memory of Colin,

the two blond boys in my life.

VIKING STUDIO
Published by the Penguin Group
Penguin Putnam Inc., 375 Hudson Street,
New York, New York 10014, U.S.A.
Penguin Books Ltd, 27 Wrights Lane,
London W8 5TZ, England
Penguin Books Australia Ltd, Ringwood,
Victoria, Australia
Penguin Books Canada Ltd, 10 Alcorn Avenue,
Toronto, Ontario, Canada M4V 3B2
Penguin Books (N.Z.) Ltd, 182-190 Wairau Road,
Auckland 10, New Zealand

Penguin Books Ltd, Registered Offices:
Harmondsworth, Middlesex, England

First American edition published in 2000 by Viking Studio,
a member of Penguin Putnam Inc.

10 9 8 7 6 5 4 3 2 1

Illustration credits appear on page 160.

CIP data available

ISBN 0-670-89259-9

Printed in Italy by Conti Tipocolor
Designed by Wherefore Art?

contents

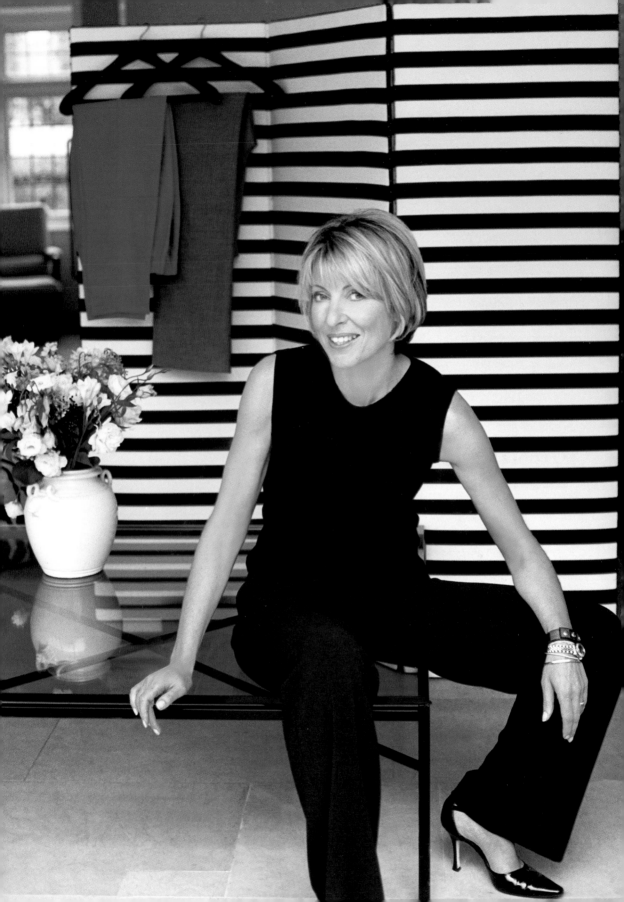

This book came about thanks to a chance call to Steve Jones, the Professor of Genetics at University College, London. The first surprising fact was that he answered his own telephone. The second was the fascinating way he talked about the blonde gene. If the Scandinavian blonde gene was recessive to everything, as he explained, then the natural blonde must be an endangered species. Imagine a world without blondes. I simply wanted to know more. Since then, many people have helped me with my investigations; photographers have given me stunning pictures, friends and colleagues have given me their time, efforts, enthusiasm, generosity and love. To them, my deepest thanks. They are:

Blondes

David Adams • Sue Baldwin • Lisa Brody • Fleur Clackson • Robert Erdmann • Jo Eaton • Jo Hansford Clare Johnson • John Lloyd • Pam Mason • Tim Rice • Cindy Richards • Katie Sharer • Jacki Wadeson

Non-Blondes

Anthony • Carmel Allen • Kevyn Aucoin • Vicky Berg • Caroline Barker • Kate Clark at L'Oréal • David Costa Robin Derrick • Martha Dulap • John Frieda • Sally Hershberger • Rachel Godfrey • Jean-Jacques Lebel • Barry Lategan • Mark Lucas • John Swannell • Araminta Whitley • Colin Webb

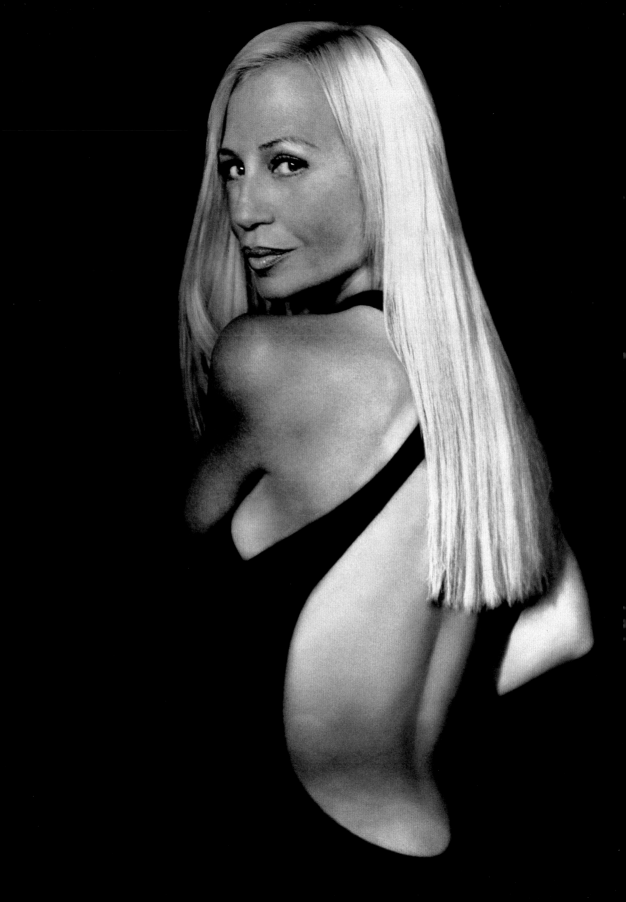

Foreword by Donatella Versace

Blondes have had some bad press through the ages but only when we have been misunderstood - normally by a brunette. Whatever you might think of Blondes, in my opinion there is a definite blonde personality.

I was always blonde, I started life as a light blonde - well maybe more of a medium blonde like my elder brother Santo. I started at the age of eleven by just putting a few highlights around my face. My brother Gianni was originally against it and my mother would have preferred me to be more conservative, but in the end my blonde tough side won through. At the time the fashion was all about the Courrèges image - defined by the dark bob rather than long blonde hair, so my decision was more personal rather than fashionable.

Over the years I have changed the tonality of my hair and have played with the shades. I have gone from platinum to warmer blonde more recently, but now I am going back to being lighter. I love the strength of white blonde. Some people talk about having disasters while dyeing their hair - in my opinion you can never have a blonde disaster. The colour disasters you normally see are brunettes with too much red or red heads with too many low lights. I am always trying the latest products - whatever is new goes on my hair.

Being blonde I use very simple make up at night. I tend to wear mainly black clothes and even at night I don't like too much extra decoration. I think that blonde hair and natural skin should win over everything else.

I am thrilled to have been asked to write this foreword, as it is time to redress the balance and fight our corner.

For me being blonde is not just having a hair colour, it is a way of being and a state of mind.

Donatella Versace

THE
VANISHING
BLONDE

GODDESS OR DYING SPECIES?

'Yea, is not even Apollo, with hair and harpstring of gold, A bitter God to follow, a beautiful God to behold?' Swinburne 1837-1909

Over the last few years, anyone whose profession it is to cover the biannual international fashion collections noticed that, as if by osmosis, all the models on the catwalk were becoming blonder. A goldrush of goddesses with hair from butter-yellow to ash have sashayed down the runway like some new genetic breed. In a sense they are a contemporary clan, since the vast percentage of their hair colouring, thanks to chemistry rather than parentage, comes out of a bottle.

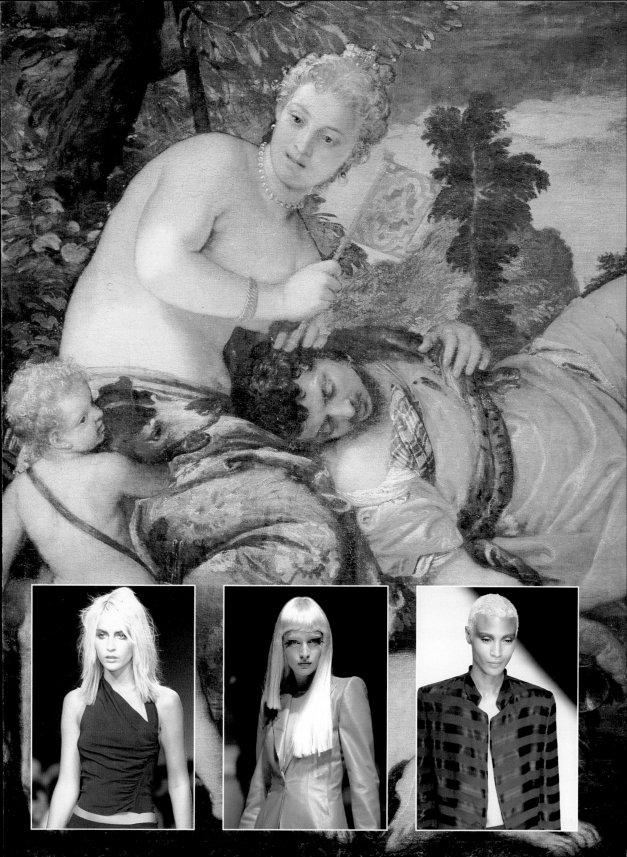

Historically, blonde hair is associated with Nordic heritage. As far back as the Romans, fashion victims of the time (always in search of something new) pillaged the flaxen plaits of northern tribes and wore them as trophies. Even then blonde hair had a rarity value and it conferred status on all those who possessed it, stolen or otherwise. Who were the northern tribes with this pure platinum inheritance? Scandinavians certainly but also the Dutch and the Germans who with their fair skin and fair hair were fair game for the marauders.

According to Steve Jones, professor of genetics at University College London, the *Scandinavian gene is recessive to everything.*

'In the primordial soup of genes caused by world migration and intermarriage the blonde will ultimately be superseded by dark-haired and dark-skinned races.' Jones blames the vanishing blonde on the invention of the bicycle without which man would never have been able to leave his original habitat, but cannot be categorical on why humans evolved light skins and hair in the first place. There are only theories as to why natural selection favours those with genes for light skins as humanity began its long walk from the sunny tropics to the gloom of Northern Europe and none of them is completely satisfactory. Apart from very blonde or very red hair, the rest of the range is genetically confused and also involves age and exposure to the sun. The fact that fair-skinned mammals have survived for thousands of years is extraordinary in itself. Migration to the dismal Northern climes may have been due to skin cancer brought on by ultra violet light although that doesn't really add up because the cancer kills you after you've passed on your genes. The idea that people in lousy climates have to maximise on their Vitamin D doesn't either. All that matters is that natural selection changes historically with patterns of population expansion. Currently experts have singled out Africa as the next continent for major population expansion which means that its peoples will travel and their dark genes will absorb fairer ones all over the world. In America, where one-third of the African gene pool is already of white origin because the intermingling of genes dates back to the days of slavery, they can already predict a time when dark skins, hair and features will predominate.

NEEDLESS TO SAY
THE ROMANS
WEREN'T TOO
ABSORBED BY THE
PRESERVATION OF
THE SPECIES AND
MERELY ADMIRED
THE HAIR OF THE
SLAVES THEY
CAPTURED.
THEY SET ABOUT
TRYING TO IMITATE
IT WITH A MIXTURE
OF ROCK ALUM,
QUICKLIME,
ELDERBERRIES,
NUTSHELLS AND
WOOD ASH
COMBINED WITH
DREGS OF WINE.
THIS POTION
SERVED AS A 'BLOND
WASH' THAT WAS
LEFT ON FOR
SEVERAL DAYS UNTIL
A REDDISH-GOLD
SHADE EVOLVED.
THERE IS NO RECORD OF THE RESULTING SMELL.

The formulation of the word 'blond(e)' is not known for certain though it may originate from the Latin word 'blandus', meaning charming or to come from the German word 'blundus', describing a person with yellow hair. It enters French vocabulary in the twelfth century and is used as an affectionate diminutive for the young as in 'blondin' and 'blondinet' although at this point in time, it was more likely to have been applied to a boy than a girl. Blonde appears in Chaucer as 'blounde', but then fades from view in English until the seventeenth century when it was almost exclusively applied in the feminine. 'Blonde' still suggested sweetness, charm, and youthfulness until the 1930s and 1940s under the influence of Hollywood when the word emerged as a noun and acquired its brassier 'golddigger' overtones.

After Rome's expansion circa 750 BC there are noticeably more paintings of blondes. The further north they travelled and the more they expanded their civilisations, the more they came into contact with fair-haired tribes. In the time of Messalina in the first century AD, hairstyles varied widely and every woman retained her own hairdresser or ornatrix. Ovid tells us at this point that blondes were very fashionable — women dyed their hair and made wigs from the hair of captured barbarians, mostly Germans. After AD 800, the Anglo-Saxon fashion for wearing the hair long (quite unlike their Greek ancestors) was reinforced by the arrival of the Danes who, needless to say, were all fair. The Danish seduction technique when it came to impressing and winning the favours of Anglo Saxon women was not unlike the later posturing of James Dean. They looked cool and took time to elaborately comb and decorate their hair.

The Italians were particularly mad for blondes. An abundance of them turn up again and again in Venetian Renaissance paintings. This may well have been artistic licence. Tiepolo, for example, even gave Cleopatra strawberry-blonde curls and blue eyes, while other Renaissance and Baroque painters conveniently forgot the origins of the mythical and historical heroes in their paintings and depicted them as beauties of their times.

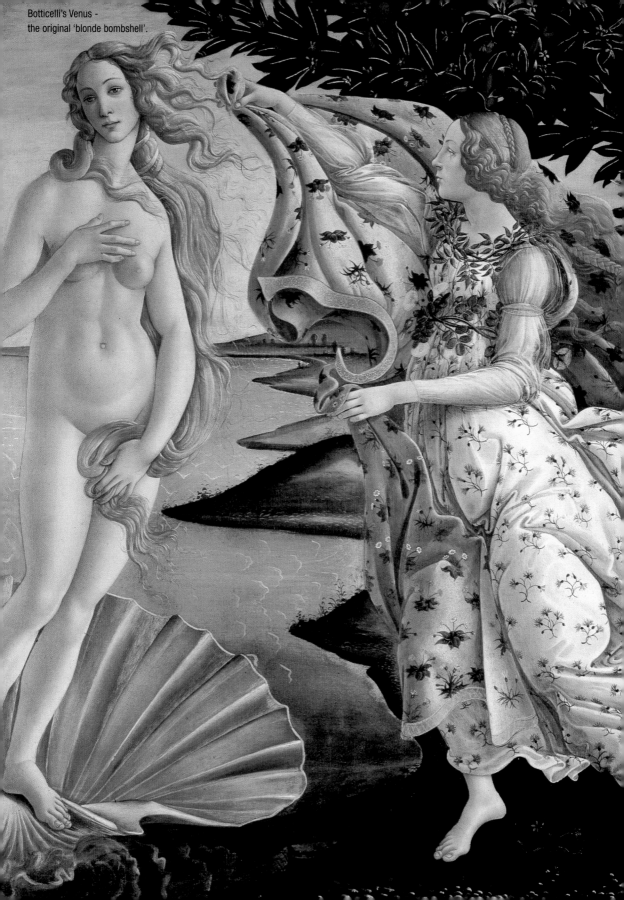

Botticelli's Venus -
the original 'blonde bombshell'.

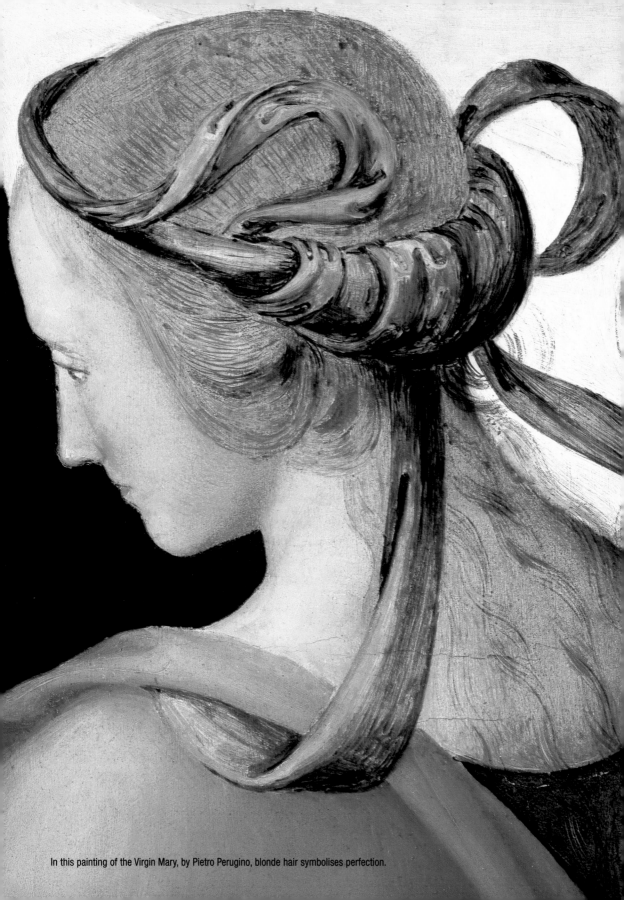

In this painting of the Virgin Mary, by Pietro Perugino, blonde hair symbolises perfection.

Where we have Hollywood and rock stars, the Romans had goddesses they wanted to emulate, and all are portrayed in paintings of the era with proliferations of blonde hair. Venus, Vesta, Proserpine, Ceres and Psyche as interpreted by Titian, Tintoretto, Veronese and Botticelli are painted with the sort of honey-coloured tresses we can acquire today with a packet of L'Oréal home colourant. At this point peroxide was still not an option. Women (and hairdressers) were to wait another three hundred years for its invention. The fact is that Venetian women had discovered several methods of dyeing their hair and there are books full of the recipes they tried, as well as records of the sunstroke, nosebleeds and burned scalps they suffered in the process.

After the fifteenth century the Virgin Mary is frequently depicted as blonde – even in France and Italy where there existed a strong cultural heritage of dark skin and hair. Blondeness not only came to be associated with beauty and perfection but soon became an indicator of virginity, youth, innocence, and also fertility. Since blondeness in antiquity was a tireless quest for status and adoration, it is not surprising that through the centuries wigs both for men and women have been a simpler way of acquiring it than the use of some lethal concoction and the sun. By the time of the Cavaliers in Britain and the sexually liberated court of Louis XIV, luxuriant locks were the ultimate status symbol and coloured powders were used to add to their decoration. By the nineteenth century gold and silver had been added to the wig-maker's colour spectrum. In spite of the demands of fashion, faking was frowned on, even back in 1664 when Samuel Pepys wrote chauvinistically in his diary about his wife's wig.

'THIS DAY MY WIFE BEGAN TO WEAR LIGHT-COLOURED LOCKS, QUITE WHITE ALMOST, WHICH ALTHOUGH IT MADE HER LOOK VERY PRETTY, YET, NOT BEING NATURAL VEXES ME, THAT I WILL NOT HAVE HER WEAR THEM.'

Needless to say, when it comes to whims of fashion, women have never taken much notice of men's opinion and by the time of Marie Antoinette and Madame de Pompadour – a big hair moment if ever there was one – yellow and white powdered wigs towered so high that every woman could be a goddess

if only through height. Madame Tallien, an influential society lady of 1796, changed her image more often than Madonna changes her hairstyle and colour. She had a large collection of wigs and would change from one colour in the morning to another in the evening.

Considering the unabated quest for blonde hair through the centuries, it seems surprising that it took so long for peroxide to be invented. The first hair bleach was advertised in the Paris Exposition by a British pharmacist and perfumer called E.H. Thiellay and one Léon Hugo of Paris, a hairdresser. It was 1867, ironically a time when dark hair was fashionable. Both the Victorians and the Edwardians admired dark hair; their heroes in literature were 'tall, dark and handsome' and in the period up to and including the First World War, hair was piled up, curled, pinned and padded but not generally coloured artificially. Elaborate styles, which involved ornaments and braiding, false pieces and pomades, were the fashion. In 1892 Isabel Mallon, writing in the *Ladies Home Journal,* made her views clear: 'It almost goes without saying that a well-bred woman does not dye her hair.'

It is worth remembering that just a decade after the invention of peroxide, the Germans embarked on a particularly unsavoury experiment in eugenics. In 1886, due to an idea suggested by Wagner, Elizabeth Nietzsche, sister of the philosopher, selected an entire community of people, specimens chosen for the purity of their blood, and shipped them off to an isolated village in Paraguay. The village still exists and is called Neuva Germania but its people are poor, inbred and diseased although they look quite different from their South American neighbours. Many have blonde hair and blue eyes. Their ancestors were chosen from the people of Saxony in order to plant the seed of a new race of supermen.
Playing God with genetics can be a dangerous game. Far better to play with what Thiellay and Hugo named 'Eau de fontaine de jouvence d'or' or 'water from the fountain of golden youth', the chemical formula they invented at the end of the nineteenth century. How prosaic peroxide sounds in comparison.

But it did the trick. After the miseries of war came the dazzling blondes and golden vamps of Hollywood and the blonde was put back on her pedestal. In the 1950s when Marilyn Monroe, the patron saint of peroxide, ruled supreme, a great jump forward in hair colouring was made with a preparation that bleached, shampooed and dyed permanently in one operation. Women became more adventurous and home hair dyes have been on the rise ever since. Today blonde is by far the most popular colour. The last seventy years has seen a transformation in the history of blondes as icons, their magical qualities diminished in contemporary culture.

HOWEVER, DESPITE THE PERVERSITY OF MADONNA, THE IN-YOUR-FACE SEXUALITY OF BOTTLE-BLONDE ROCK STARS, THE ANGELIC, YET MANIPULATIVE PERSONA OF THE PRINCESS OF WALES AND THE LADDISH BLONDES AND DIZZY WEATHER GIRLS WHO NOWADAYS REPRESENT THE DUMBING-DOWN OF A TYPE, BEING BLONDE STILL HOLDS PROMISE FOR WHOLE NEW GENERATIONS. THE STATISTICS IN HAIR COLOURING ALONE TELL US THIS. SHE MAY BE A DYING SPECIES, BUT THE BLONDE WILL ALWAYS BE AS PRECIOUS AS THE GODS AND MADONNAS OF MYTH AND LEGEND. THERE IS NO DOUBT THAT IN THE FUTURE, FASHION (AND HAIRDRESSERS) WILL KEEP ON RE-INVENTING HER.

THE CHEMISTRY OF BLONDE

The chemical process for the bleaching process =

$$2H_2O + 2OH_2O$$

HYDROGEN PEROXIDE WAS DISCOVERED IN 1818 BY THENARD BUT THERE WAS LITTLE PRACTICAL APPLICATION OF IT UNTIL 1867. AT THIS POINT IT WAS PROMOTED BY E.H. THIELLAY, A PHARMACIST AND PERFUMER OF LONDON AND LEON HUGO, A PARIS HAIRDRESSER IN THE PARIS EXPOSITION. LITTLE DID THEY KNOW WHAT THEY WERE STARTING. USING A 3% SOLUTION OF HYDROGEN PEROXIDE UNDER THE TRADE NAME OF 'EAU DE FONTAINE DE JOUVENCE GOLDEN' THEY DEMONSTRATED ITS BLEACHING EFFECT ON HAIR AND IT QUICKLY BECAME POPULAR THROUGHOUT EUROPE AND THE UNITED STATES SUPERSEDING EVERYTHING ELSE THAT HAD BEEN USED BEFORE. A HUNDRED YEARS ON, SALES OF HOME HAIR COLOUR IN THE USA TODAY, ARE NOW ESTIMATED AT WELL OVER $1 BILLION DOLLARS.

Women have always been dissatisfied with their hair colour.

There are mentions of hair colourants or at least of substances applied to the hair in an attempt to change its colour throughout history from the earliest Egyptians as well as in the historical records of the Greeks, Hebrew, Assyrians, Persians and even the ancient Chinese. Of course, since hair colouring was originally an attempt to cover grey hair, it was often kept a secret. Some recipes for early dyeing were written down in medical books, particularly during the Renaissance. Romans coveted the hair of their Nordic captives and primitive methods for bleaching hair to 'get the look' at the beginning of the Christian era included minerals such as quicklime, rock alum, crude soda and wood ash usually combined with old wine and water. Blond washes were mentioned in Pliny during the Early Empire period between 27 BC and AD 69, at least 1400 years before America was discovered. One recorded bleaching mixture involved mullein flowers in vinegar. The flowers of verbascum lychnitis, its Latin name in Culpeper's seventeenth-century herbal, were normally distilled and used for gout, toothache or as a cold remedy. But Mullein and Mastic (a French herb) were also being marinated to use as a blond wash. Even more popular with the Romans was a soap imported from Germany (or Gaul) made from goat's fat and ashes of beech wood in a form called 'Mattaic balls'. Soap, it seems, being more popular for bleaching the hair in those days than it was for washing.

A couple of hundred years later women still longed for fair hair. Fifteenth-century Venetians wanted to emulate the fabled beauties of Grecian antiquity. Whether painters like Titian and Tintoretto started this blonde trend with their portrayals of the goddesses Venus, Ceres, Psyche and Proserpina on canvas, or whether it was the fashion of the moment, is difficult to assess. But there is an intriguing abundance of blondes in Venetian paintings of this era compared to say, the pre-Raphaelites who loved redheads, or the Impressionists who mostly went for natural brunettes. This could be explained in two ways. Intermarriage of the northern tribes who invaded the Italian peninsula may well have left a genetic strain of fair-haired families or fashionable painters may simply have taken a great measure of artistic licence.

Biochemist Konrad Bloch set out to prove that a more likely hypothesis for this wave of blonde beauties in secular art was due to chemistry not genetics. He argued that the Venetians had learned how to bleach their hair with a chemical substance which, although not peroxide, did the trick all the same. Females in art of this period are not blue-eyed as would mark a natural blonde, but brown-eyed, he pointed out, and the male gods such as Mars and Adonis that accompanied them in the paintings generally had dark features. Two chronicles written in the late nineteenth century – 'Les femmes blondes selon les peintres de l'ecole de Venise' by Armand Brachet and Felix-Sebastien Feuillet de Conches (1865) and an Italian account by Guiseppe Tassini, 'Curiosita Veneziane' (1887) – confirm that Bloch wasn't the first to address the question of whether Venetian blondes were natural or fake.

There is both pictorial and written evidence in Renaissance times of the lengths women in Venice, Florence and Naples would go to, to turn a golden hue. There are historical references to Lucrezia Borgia travelling to meet her third husband and stopping en route to restore her

hair to the blonde shade she desired. Other society women spent hours on the balconies (*terazzi*) of their mansions and *palazzi*, bathing and rinsing their hair with a tincture known as *aqua bionda* or *aqua di gioventu* then drying their tresses, sometimes repeating the procedure several times. As part of the process, they typically wore a crownless straw hat with a wide brim called a *solana*.
The wide brim shaded their faces and skin from the sun and its damage, while their hair was combed out over the brim and exposed to the midday rays.

Needless to say, there are records of women getting not only sunstroke, but headaches, nosebleeds and even blindness in the pursuit of their desired buttery shade. The dangers of a handful of the ingredients were self evident in a report in 1562 by a Dr Marinello of Moderna (Modena) which listed mixtures of alum, black sulphur and honey as being commonly used for bleaching. It was a combination of components that not only caused the hair to fall out altogether (it didn't only happen in Hollywood) but also seriously damaged the complexion.

'Permit me to remind you honoured and honourable ladies,' he wrote, 'that the application of so many colours to your hair may strike a chill into the head like the shock of a shower–bath, that it affects and penetrates and what is worse, may entail divers grave maladies and infirmities; therefore I should advise you to take all possible precautions... we frequently see the hair affected in its essentials, or at its roots grow weak and fall off and the complexion destroyed through the use of so many injurious liquids and decoctions.'

But when did any woman, ever eager to suffer for beauty, listen to words of warning? No less than 26 recipes for Aqua Bionda are listed by Brachet with a special reference to number 24 as being the most popular among the blond-mad Venetians of the fifteenth century. The application of *aqua biondas*, coupled with the sunbathing techniques of the Italians, were introduced into France late in the sixteenth century by Marguerite de Valois and with slight modifications this treatment remained for over two hundred years the acceptable method for producing blond and reddish shades of hair. Every one of the recipes specifies aqueous extracts of various plants as starting materials. A selection of some of the following were marinated together according to the recipe you chose:

Plants extracted:
Licorice (glycerin), boxwood, flowers of walnut, myrtle leaves, cypress blossoms, cumin (herbal medicine), lupin, myrrh (sweet cicely), dregs of white grapes, buds of poplar, madder root (contains alizarin, orange-yellow red), clover, holly, aloe, ashes of grape vines.

Chemicals:
Saltpetre, powdered silver, quicklime, alum (used for bleaching raw silk), wood ash (potassium carbonate).

The recipes themselves, each one with a different mixture of plants and chemicals in differing quantities with varied ways of application and lengths of developing time, are written in a wonderfully conspiratorial way- a sort of fifteenth-century advertising-speak.

Where an old Mrs Beeton recipe might encourage you to 'take 10 plovers eggs' or '100 cloves of garlic,' as the ingredients for a Victorian delicacy, one of Giovanni Marinello's blonding prescriptions might request 10 drachmes of lupins, very finely shredded, five drachmes of myrrh and three of saltpetre. This promised (although both messy and smelly) to make the woman who used the concoction 'one of the happiest women in the world, because you will be blonde and brilliant'; waxing even more lyrical 'your hair will be so blond as to shame a strand of golden thread' and, more obviously, 'your hair will look like gold'. If Marinello had been a copywriter for L'Oréal today, he would probably have come up with a line not a million miles away from 'Because I'm worth it.'

In 1987, L.J. Wolfram and L. Albrecht wrote a definitive paper on the photo-bleaching of brown and red hair from the Clairol Research laboratories. After carrying out extensive bleaching experiments with human hair, their principal results illustrated clearly how both solar radiation and oxygen are needed for bleaching. Their formulation for the bleaching process at the top of the page, and their research among other things, confirmed that the ancient procedure for bleaching hair with *aqua bionda* was a process quite in harmony with modern chemistry. Except that there must have been a chemical in plant extracts used then that plays the peroxide role. Whether or not the medics prescribing and mixing the washes knew how potent their concentrations were is debatable. Was it trial and error? Was it alchemy? Did the women of the time, so bent on following fashion, understand the chemistry? Did they care? The answer of course is: probably not.

THE FAIRYTALE BLONDE

'Once upon a time there lived the daughter of a king. Her hair was finer than gold and marvellously, wondrously blonde, all curly and fell to her feet. She was called Beauty with the Golden Hair.'

La Belle aux Cheveux d'or by Mme d'Aulnoy

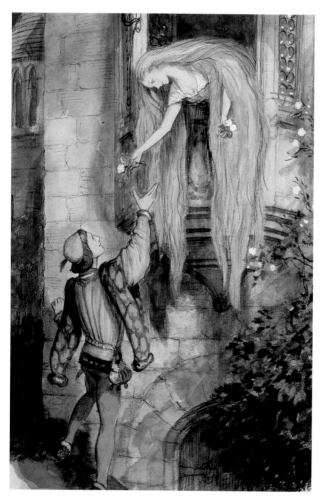

Golden hair tumbles through any amount of fairytales. As mothers the world over read bedtime stories to their children, lines such as 'You shall be beautiful and your hair shall be golden' tell tales of rags to riches, frogs to princes, glass slippers, seven league boots, enchanted forests and thousand-year sleeps. Grimm's Rapunzel lowers her long fair hair out of the high tower as a rope for her guardian witch to climb up, Queen Titania in *A Midsummer Night's Dream* combs Bottom's hair without feeling an ass, while Rumpelstiltskin stamps his foot until he splits in half after the maiden whose flax he has spun into gold guesses his name and is thus released from her promise to give him her child once it is born.

In fairytales, heroes are clean and flaxen-haired, while their enemies are hairy, dark and ugly. But their hair is not only a thing of beauty. It also has magic powers: strong enough to use a rope ladder in Rapunzel and as a powerful aphrodisiac in *Pelleas and Melisande*, where the touch of her long fair hair falling around Pelleas's head is what causes him to fall in love. Hair was used in spells and curses and often worn as a trophy by medieval knights while their damsels chose a lock of hair as a good luck charm. Galahad wears a belt woven from Dindraine's hair in Malory's *Le Morte D'Arthur* which together with her vow of chastity is strong enough to protect him from harm.

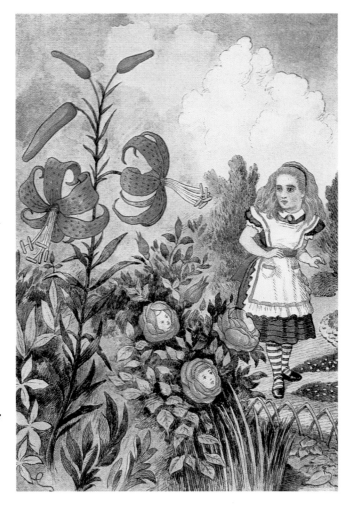

While hair was symbolic in itself, the nature of golden hair not only suggests goodness, as in Tiepolo's painting of *Vice and Virtue*, where Virtue has pure blonde hair while her enemy Vice is dark. In fairytales it also suggests strength, untarnished brightness, indestructibility and high value so that the virtues of the precious metal become characteristic of the wearer.

Cinderella, although her image changes with fashion, is always blonde, as is Alice in *Alice in Wonderland* and countless nursery rhyme characters such as Little Miss Muffet and the green-fingered Mary, not to mention the goody-goody Goldilocks, an innocent curly-headed blonde saved and cherished by the bears. As well as goodness and beauty, blondeness suggests birth and youth (the adorable fluffy-haired child can be compared allegorically to the new-born baby chick and duckling).

Every one of these attributes has
been depicted in visual imagery
through the centuries, ever since the
time of Homer's golden-haired king
Menelaus and the queens and
goddesses of ancient Greece such as
Aphrodite and Helen. Blonde
beauties appear in medieval
tapestries; in Botticelli's painting
Venus rises from the sea with
nothing but her blonde hair to clothe
her; in Virgil's *Aeneid* Dido's hair is
described as *flavae*, meaning golden
while Jason and the argonauts on
their quest for the golden fleece had
to resist the temptations of siren
mermaids, their golden tresses
tumbling hypnotically into the sea as
they lured sailors to their deaths.

*Blondeness suggests
lightness rather than yellowness,
the glow of gold, a crowning glory –
'trezze d'oro' in Italian – a
heavenly luminosity or even a
solar radiance.*

In fact, meteors were called 'comets' after the
Latin word *comes*, meaning hair, named for the
flowing golden tail of hair as they flashed through the sky.

In the middle ages a 'fair' used to be a noun meaning a beauty, and indeed *La Belle aux cheveux d'or* was translated in the eighteenth century as *The Fair with the Golden Hair* revealing an association between fairies and fair ones. The root may be the same for the words 'fay' and 'fair', the Middle English *feyen*. From fairies to virgins, the astrological sign of Virgo is also portrayed as a blonde. The sign symbolises the sunny months of August but more importantly, during a time of fertility, fecundity and the harvest, the ears of wheat and corn visually echo the long plaited golden hair of the virgin. Similar to any number of fairytale heroines, Virgo is shown with an abundance of lengthy and complicated plaits, ringlets and curls. Her hair cascades to her waist and even to the floor, maidenhair symbolising maidenhead – or the loss of it. In other fables, from the fifteenth century onwards, the loss of this golden accessory may well symbolise the loss of virginity but more often it is simply a punishment for being bad. In one French story the bad sister grows stinking weeds and rushes on her head instead of hair after refusing to do a favour to the ugly villain of the tale. Her sister, who was kind and cared for him, is rewarded by golden sheaves of corn and precious jewels. In another story the kind sister has roses, jasmine, rubies and pearls pouring out of her hair as she combs it while the wicked sister with the 'evil tongue' is stuck with a donkey's tail forever growing out of her forehead. In a turn-of-the-century French tale, *Blonda and the Fairy Caprice*, Blonda's beautiful golden hair falls out because she is greedy and selfish and she has to earn back each hair on her head through good deeds and generosity while in *Donkeyskin* by Perrault (who also wrote *Cinderella*) the beautiful princess runs away from her would-be incestuous father disguised as a donkey until at last a prince arrives to save her.

The point of fairytales is to enchant and intrigue but also to set an example. We may be entertained and educated but those bedtime stories are there to teach us something. When it comes to blondes, the moral is clear. The golden-haired heroine is precious and rare and exasperatingly good. Time and time again, it's the blonde princess (as opposed to her darker siblings) who, after dispensing with goblins, dragons or evil witches, is destined to live happily ever after.

The Psychology of Blondes

To some women there's no such thing as blonde enough but what is the personality of the true blonde, platinum to the bone? Sunny and bright like Lorelei Lee, Anita Loos's ingenuous heroine in *Gentlemen Prefer Blondes* or devious and shallow like Becky Sharp in Thackeray's *Vanity Fair*? Flirtatious and extravagant like Rosamund in *Middlemarch* and Lydia Bennet in Jane Austen's *Pride and Prejudice* or goody-goody like Lucy Deane in George Elliot's *The Mill on the Floss* and too-good-to-be-true-Beth in Louisa M Alcott's *Little Women*? Literary and film blondes cover a gamut of personalities from the deeply dippy Marilyn in *Some Like it Hot* to the sad, somewhat faded heroine in Dorothy Parker's short story, *Big Blonde*, not forgetting the frightening gold-eyed, golden-haired mystery children in John Wyndham's *The Midwich Cuckoos*, filmed as *Children of the Damned*.

Blonde is a powerful colour. It can say 'cool', 'brash', 'innocent and fragile', 'dizzy', 'stupid', 'brassy', 'raunchy', 'glamorous' and 'intimidating'.

Hair colour is the root of a girl's personality according to a 1997 university research paper by experimental psychologist, Dr Tony Fallone. Blondes are more likely to be outgoing and lively and are perceived as more feminine than their brunette or redhead counterparts. Blonde is not a colour then, but a state of mind. Because blondes see and feel themselves as more glamorous they project this so that others also see them this way. The thing about being blonde is that you are noticed more. Blokes in vans turn round and look – perhaps simply because the colour just catches the eyes. So, if you decide to become blonde, you decide to

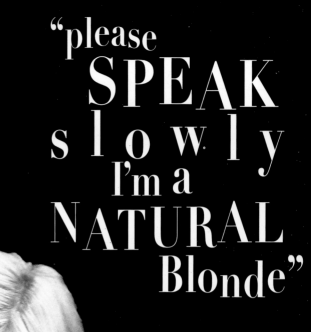

"please **SPEAK** s l o w l y I'm a **NATURAL** Blonde"

Nadja Auermann, whose bank balance proves she's far from dumb.

For Anne Gregory

'Never shall a young man
Thrown into despair
By those great honey-coloured
Ramparts at your ear,
Love you for yourself alone
And not your yellow hair.'

'But I can get a hair-dye
And set such colour there
Brown, or black, or carrot,
That young men in despair
May love me for myself alone
And not my yellow hair.'

'I heard an old religious man
But yesternight declare
That he had found a text to prove
That only God, my dear,
Could love you for yourself alone
And not your yellow hair.'

W. B. Yeats.

be noticed and therefore you have to adjust. This is entirely different from being born naturally fair. Today does not favour natural blondes except in Scandinavian countries, where your passport specifies what kind of blonde you are: dark, medium or pale, and where the assumption is that your hair colour is genetically pre-determined.

For the rest of the world, even the real thing can now be mistaken for fake thanks to the subtle arts of the hairdresser. Born blonde and shy you are likely to have a hard time of it. Take bottle brunette, Winona Ryder who claims that she is not only blonde but in reality almost white. 'I've got dark brown eyes and very pale skin,' she says, 'I look seriously weird unless I dye my hair and eyebrows dark. I also feel much more like a dark-haired person than a blonde. People expect you to be bubbly if you're a blonde. I'm quite serious, so I feel this is my natural colour.'

Poor real blondes. Once a rarity, these mythical goddesses, both revered and adored, are now the sex kittens of contemporary culture: bombshells, bimbos, carry-on heroines and weather girls, all faking it with attitude. Where brunettes smoulder with knowing allure because mystery is their secret weapon, blonde sexuality incorporates innocence and naivety; the T-shirt slogan that reads 'please speak slowly I'm a natural blonde' saying it all. Gentlemen prefer blondes but marry brunettes. **Who gets the better deal?**

The dark or the fair?

Blonde is deemed vulgar past a certain age and bleached hair linked to leopardskin and heavily outlined pouting mouths, conjures up a further perception of blondes as brassy,

blowsy and further down the line – as potential transvestite or gay icon. David Hockney brought the house down with his impersonation of Marilyn Monroe at a Royal College of Art Christmas Revue. Ru Paul in blonde wig and shaved legs has successfully followed his lead.

Since hair colour is a secondary sexual characteristic, both length and colour of hair gives out signals. Sex symbols like Farrah Fawcett Majors, Marilyn, Brigitte Bardot and Madonna all had long (and blonde) hair at the height of their popularity; remember that Bo Derek with her golden braids was awarded a '10' in the 1–10 scale of perfect womanhood. Equally, when Veronica Lake was made to tie her hair back for a visit to a munitions factory, her popularity plummeted almost instantaneously.

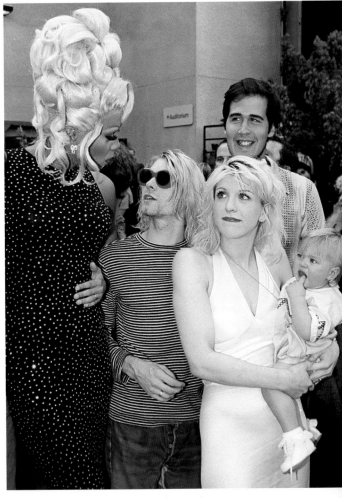

A blonde trio – Ru Paul, Kurt Cobain and Courtney Love.

'Any time we girls have to go to work the result historically is that we do things better than the opposite sex. I mean gentlemen will go to all the trouble of keeping office hours and holding Board Meetings and getting Mr Gallup to make a poll, and sending their Public Relations agents to Washington, in order to reach a decision which any blonde could reach while she was refurbishing her lipstick.'

Anita Loos, 1951

However being blonde is a complex matter since the subtlety of shade appears to change the perception. 'The assumption is the lighter the hair, the lower the intelligence,' says Stephen Bayley, author of *Taste: The Secret Meaning of Things*. In Hollywood, his theory is borne out as a fact of life. Ellen Barkin lightens her hair for sexy roles and darkens it for serious ones. Stereotypically brainy blonde actresses, who include Jodie Foster, Jessica Lange and Michelle Pfeiffer, mainly stay with light brown, but toy with blonder as a strategic move.

But Gianni Versace believed that women liked being blonde. 'It's a triumph of femininity, –like a cult.'

Changing your hair colour may even help you change your personality. We tend to cut off our hair at the end of a love affair or change the look as we change our lifestyles, jobs, partners. This can have good and bad repercussions. Poet Sylvia Plath had a peroxide summer after her first mental breakdown while Madonna's hairdresser Luigi Murenu links her current darker persona to her reaching a new level of maturity. 'Before this darker, quieter phase, she used other women (Marilyn?) as reference. Now she's exploring her own style, she has more confidence.'

There are those who think Uma Thurman, a fine Scandinavian blonde by birth, never looked better than in her brunette wig for *Pulp Fiction*. 'It's all about the moment in your life,' says top model Eva Herzigova whose career and marriage happened at meteoric speed when she was ash blonde. Now separated and working regularly and more discreetly round the world she says, 'At this moment I'm so much happier being dark.'

Women have had conflicting feelings about naturalism and artifice in different eras – they were happy to dye in the fifteenth century and yet considered it deeply vulgar in Victorian times. Blatant hair colouring has its more and less fashionable moments. There's no doubt that the colour and length of our hair and how we display it echoes our sexual feelings, aggressions and inhibitions. 'Bad Hair Day' can really be interpreted as 'not feeling sexy' whether it's blonde hair, bleached hair or not.

PEROXIDE
PLAYMATES

'All that tits 'n' ass, the bullet bra, the cinched-in waist, the sewn-on dress. It all added up to the "ooh it's a blonde" sex factor.' ART LUNA ON HOLLYWOOD STYLE.

Numerous stars were created by the Hollywood publicity departments in the years between the Thirties and Fifties and the 'peroxide blonde as sex kitten' was the strongest image of this era. It was as if the discovery of peroxide was for all to try. If the studio wanted to sell you as a fluffy blonde then you went along with it (even if your hair fell out afterwards). The Thirties in the US was a time of depression, and the big studios, MGM, Fox, Paramount, Columbia and Warner Bros, set out to produce escapist films, all glamour, fantasy and wish-fulfilment to woo the public back into the cinema. There were musicals like *The Great Ziegfeld* and *42nd Street* with Busby Berkeley's dazzling routines; there were gangster movies and there were 'women's films'; romances with a sting in the tail that made Miss Average who came to see them feel that her own life wasn't so bad after all. Due to the serious slump in audiences in the early Thirties, the Hollywood dream factories needed to come up not only with enticing films but also inspirational stars. Anita Loos had written *Gentlemen Prefer Blondes* in 1925, the gold-digging life story of her dizzy blonde heroine, Lorelei Lee, whose philosophy was that 'a girl with brains ought to do something else with them besides think'. Lorelei single-mindedly devotes herself to a lifestyle paved with orchids, champagne and diamonds. The studio snapped up the story and set out to prove Loos's theories by bringing her heroine to life. If blondes attracted maximum attention then they would prove to be good box office. The packaging of the platinum goddesses began. Nothing looked more sensational

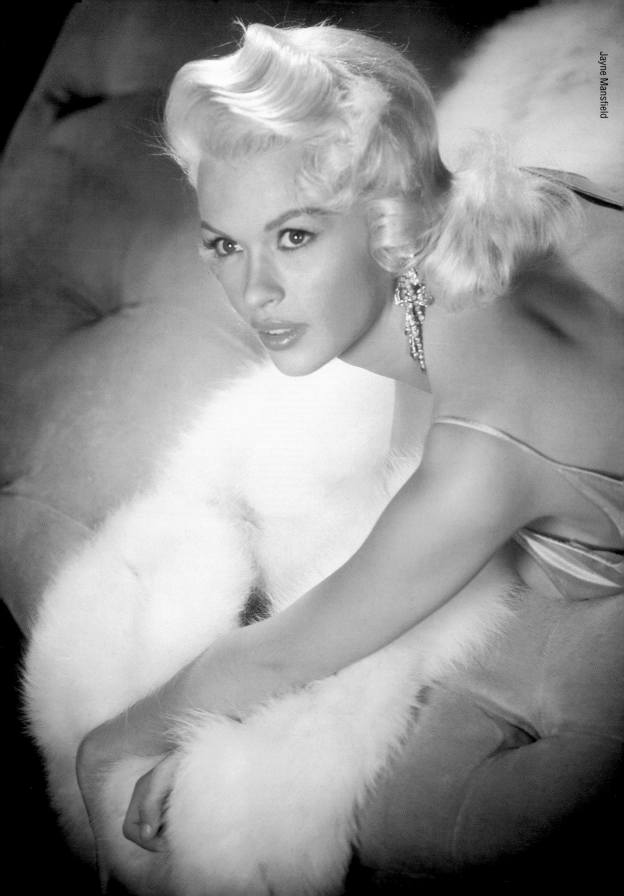

Jayne Mansfield

on black and white film than almost white hair and dramatically dark eyes. Hollywood hairdressers took to the bleach with a vengeance and the dye was cast with Jean Harlow who seemed immediately comfortable with her manufactured image. Harlow was the first and best of a new type – the brassy blonde with a sense of humour, voluptuous and sexy, tough yet vulnerable with a head and a heart of gold. She was seventeen when Ben Lyon (who incidentally later discovered Marilyn Monroe) discovered her in 1928 and her hair was already very blonde.

As time went by and the bleach stripped it paler, her signature style became more and more platinum and the press made quite a fuss of the fact that she also dyed her pubic hair to match. This could not have been an attempt to pass herself off as a natural blonde. It was probably because her wardrobe was predominantly white and often bias-cut and clinging. The general silhouette would have been less impressive with a triangle of dark hair showing. Important as her hair was to her image it was impossibly difficult to light by the studio photographers without it looking cheap.

Harlow was good at the wise-cracking one liners and she had a great body, but her crimped and white-blonde hair began to look horribly like cotton wool.

TALENTED CAMERAMEN LIT FILMS TO ENHANCE THE LOOKS OF THE STARS AND CLARENCE S BULL AT METRO-GOLDWYN-MAYER CAN BE CREDITED FOR DISCOVERING AN EFFECTIVE TECHNIQUE FOR MAKING JEAN'S OVERPROCESSED BLONDE HAIR LOOK STUNNING. THE TRICK WAS A SURGEON'S LAMP WHICH HE 'LIFTED' FROM A MOVIE SET BECAUSE IT COULD BE AIMED AND FOCUSED WITH MORE FLEXIBILITY THAN THE OTHER LIGHTS IN HIS STUDIO.

Arthur Miller, another skilled cameraman, became known for his technique of lighting baby, bubbly blonde, Shirley Temple. 'I always lit her so she had an aureole of golden hair.' he said. ' I used a lamp on Shirley that made her whole damn image world famous. It was a lamp that everyone uses now in television, it had a 250-watt bulb in it with a special piece of metal on the front of it, so all you got on her was

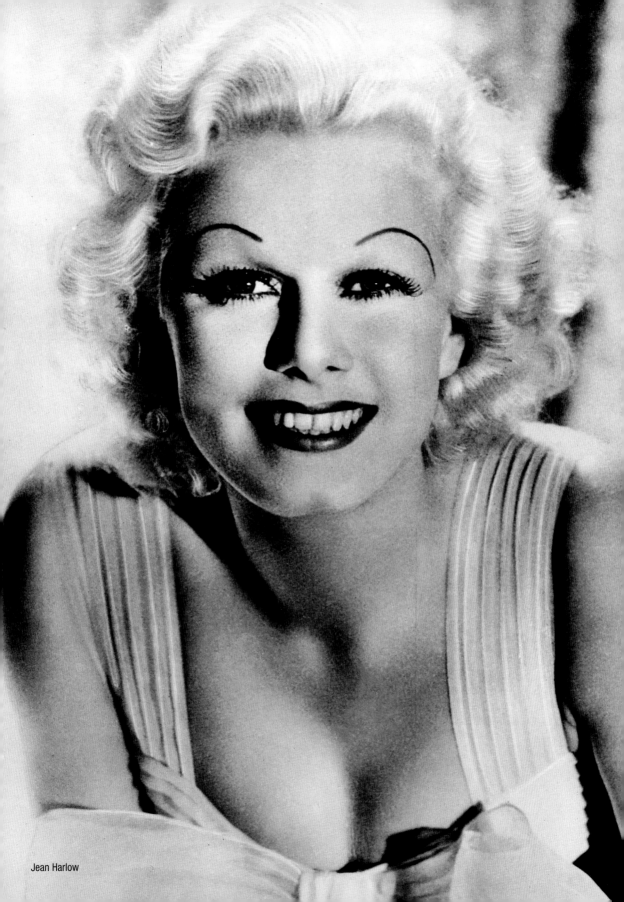

Jean Harlow

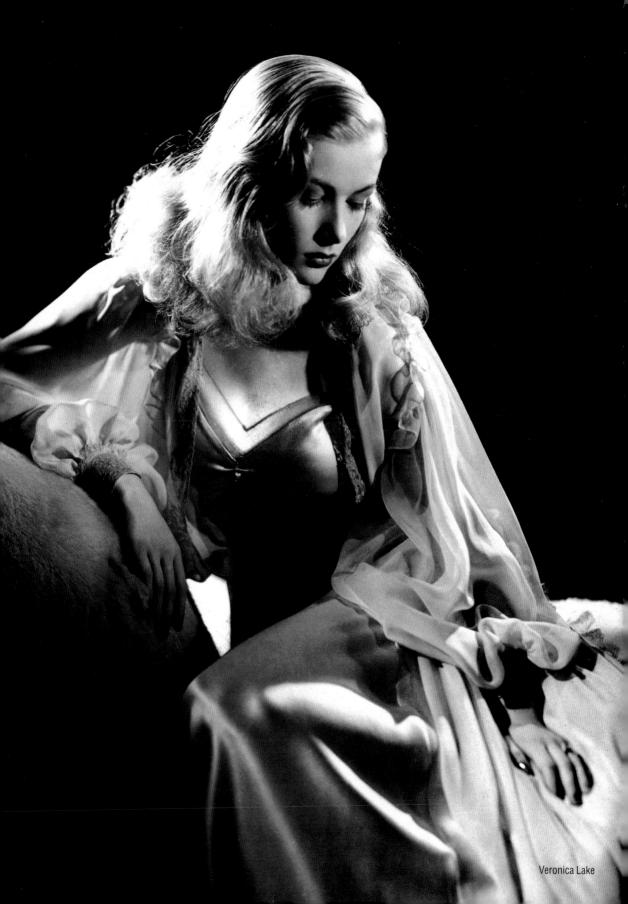

Veronica Lake

light. I had a little rheostat and I'd play a game with her as I'd turn the light up and down. I always kept the key light up, well over her eyeline, and I'd surround the camera itself with black velvet. She'd look right into the black velvet, even on exteriors. I'd light the actor she was talking to under normal, so she was in high key and he was in very low key; this gave her the star build-up you see.'

By 1932 Harlow hardly needed star build-up. She moved to MGM to make *Platinum Blonde* and although she only had third billing, she was already what we think of as the archetypal Hollywood star, the platinum blonde. Women all over America dressed like her and copied her hair, make-up and mannerisms which led to the founding of Platinum Blonde Clubs in at least a hundred cities across the continent. She was not a bad actress either. Opposite Clark Gable in *Hold Your Man* and John Barrymore in *Dinner at Eight*, Harlow held her own. In *Blonde Bombshell* she played an actress glamorised and publicity-pressurised into an idol, a plot that was obviously somewhat autobiographical.

Harlow's death in 1937 of uremic poisoning was sad and untimely. Several scurrilous stories in the press at the time actually suggesting inaccurately that she'd been poisoned by the bleach she used on her hair.

More of a package and certainly less of an actress, Veronica Lake's shining blonde hair, hanging over one eye in what journalists christened the peek-a-boo bang was the only thing that made her headline material.

Paramount Studios launched her as a sultry, kittenish sex object who pouted from behind the flopping golden curtain in numerous portraits taken for their major publicity campaigns. Sadly, she was rather better two-dimensionally than she was on screen, unlike Carol Lombard who understood camera techniques and knew how to make the studio lighting work for her. During the war effort Lake was sent out to give morale-boosting visits to the troops and obliged to be photographed with her hair tied back. This may have set a good hygienic example when visiting factories and so on but it was bad for her image. A few pictures without the siren fringe and her popularity ratings plummeted.

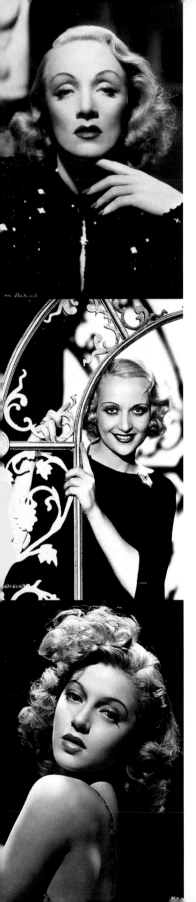

Lombard and Lake were both famously and successfully blonde in the Thirties, as were a string of young actresses including Alice Faye, Paulette Goddard, Loretta Young, Ida Lupino and Joan Blondell, all more or less created in Harlow's image. Even Marlene Dietrich, Joan Crawford and Greta Garbo toyed with the blonde bombshell look for a short time when it seemed that everyone had to.

BETTE DAVIS PLAYED THE BLONDE GAME TOO THOUGH WHEN REMINISCING LATER SHE FOUND THE WAY HOLLYWOOD HAD TRIED TO GIVE HER GARBO LIPS AND HARLOW HAIR RATHER RIDICULOUS. 'ROMAN FREULICH WAS THE FIRST PHOTOGRAPHER TO DO A SITTING WITH ME WHEN I GOT TO CALIFORNIA,' SHE SAID. 'THEY CALLED ME "THE LITTLE BROWN WREN" BECAUSE WITH HARLOW AROUND, MY HAIR WAS JUST MOUSY.' INTERESTINGLY ALTHOUGH SHE SUCCUMBED TO THE PLATINUM IMAGE FOR A WHILE, BY 1939, ONE OF HER BEST YEARS ON SCREEN, DAVIS HAD ALREADY GONE BACK TO LIGHT BRUNETTE AND NOT REMOTELY SUFFERED CAREER-WISE.

In 1934 Max Factor opened their make-up studio (a testament to Art Deco architecture) with four make-up rooms, one for every hair colour. Needless to say, Jean Harlow cut the ribbon for the 'Blondes Only' room and Ginger Rogers opened the 'Redheads Only' one, even though she is primarily remembered as a blonde.

Max Factor's contribution to the world of make-up is legendary but not so well known was the Max Factor hair department, which created wigs for the whole motion picture industry. For MGM's production of *Marie Antoinette* in 1938, the Factor hair department supplied more than 900 wigs made of pure white human hair (most white wigs before and after were made from Angora or refined yak). Factor only used virgin hair that

Marlene Dietrich, Carole Lombard, Lana Turner and Bette Davis.

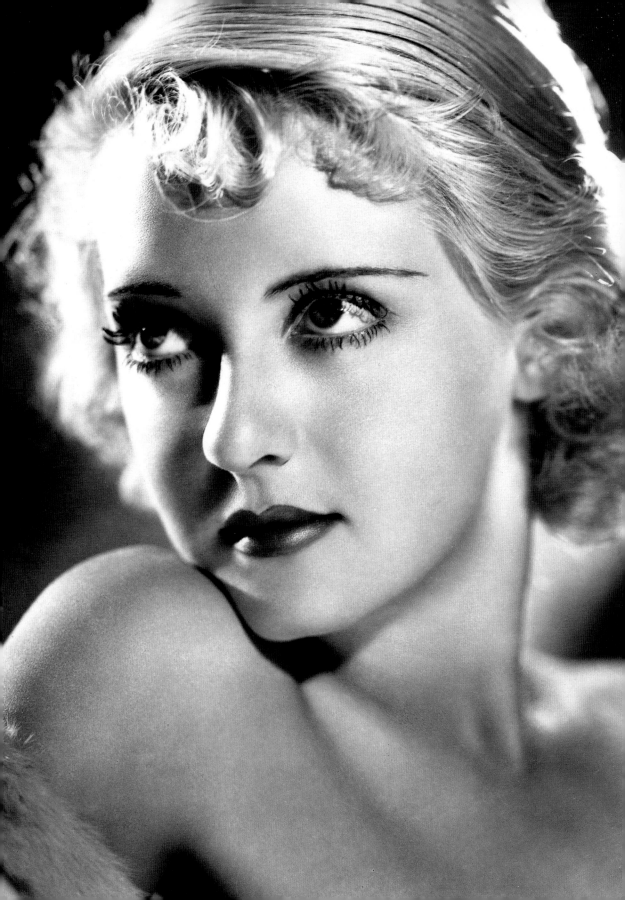

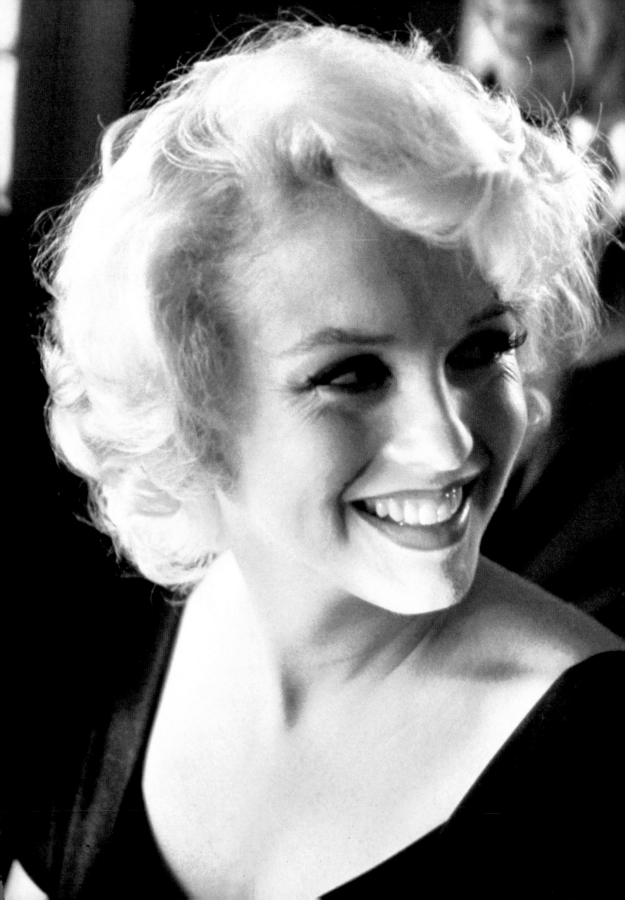

had never been touched by hair colour. He found this in Europe, in small towns far from the cities. Some areas were so remote that the women were paid in pots and pans or other household goods since money had no value to them. Long, pure white hair was the most costly and the wigmakers who handled it often wore sunglasses as handling it caused 'snow blindness'.

1935 saw Becky Sharp arrive on the screen: the first feature in three-colour Technicolor. Taken from the classic novel, *Vanity Fair*, Thackeray's heroine is described as 'small and slight in person; pale, sandy-haired, and with eyes habitually cast down'. One of the first literary blondes to be immortalised in celluloid, Becky Sharp, like Anita Loos's Lorelei Lee, soon became a template for a clutch of Smart Blondes masquerading as dizzy ones, who appear in both literature and film. Since blondes proved to be good box office, the word came up again and again. *Blonde Bombshell*, *Don't Bet on Blondes*, *Blonde Crazy*, *Platinum Blonde*, *The Adventurous Blonde*, *Blonde Fever* and *Blonde Inspiration* were all films of the era. They didn't necessarily have a blonde central to the plot, but with the 'B' word in the title the studios hoped to have a sure crowd-puller at a time of recession.

In 1939 the staggering success of *Gone With the Wind* and its dark and troubled but beautiful heroine may have marked the end of an era for the Hollywood bombshell until she surfaced again, a little brassier but still iconic with the arrival of

Marilyn Monroe

It was Miss Snively, head of Blue Book model agency who told Marilyn to bleach her hair and cut a quarter of an inch off one of her high heels to give her a wiggle. What if they'd never met?

Perhaps there was no time to go to the hairdressers during the war years of the Forties, although the movies of that time were no less escapist and glamorous. There were the musicals *Oklahoma* and *South Pacific* and there were dazzling stars like Ava Gardner, Vivien Leigh, Rita Hayworth, Lana Turner, Barbara Stanwyck, Joan Crawford, Katharine Hepburn and Deborah Kerr. It was without doubt a brunette moment – the frivolity of blonde hair somehow inappropriate at the time of Pearl Harbor and Hiroshima.

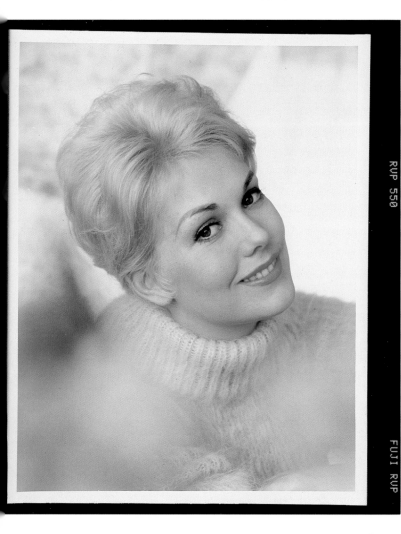

Kim Novak

When it came to the Fifties the big Hollywood studios had a new marketing task. The public now had their own televisions and were happily ensconced with entertainment in their own homes. To be lured back into the cinema the studios needed new icons and new ideas. First they came up with technology in the form of king-size screens and 3-D gimmicks, then epics with production costs far beyond anything on the smaller screen.

Columbia Studios looked back to the Thirties and came up with the idea of packaging Kim Novak as a contemporary Jean Harlow. Her hair was bleached to platinum and she was promoted aggressively as a sex-goddess in provocative poses. The lightening and launching of Novak was ruthless and focused but it worked. 'What was spectacular about her,' says Orlando Pita, today's most cutting-edge international hairdresser, 'was that particular shade of beige blonde – it still looks very new.' Novak made some good films but could never get over the idea that she, like Marilyn Monroe, had been regarded by the studio bosses as 'pieces of meat to be packaged and sold across the counter'.

The Fifties blonde was sold as a sex kitten but Marilyn Monroe's perfected dumb act is more childlike than animal. The Patron Saint of Peroxide is the one who set up a new stereotype for blondes, a combination of innocence and knowing sensuality, the pale golden hair of child (or even a fluffy duckling) in glaring contrast to the voluptuous curves of a grown woman, the lisping baby voice in opposition to the seductive behaviour. With Harlow and more importantly, Monroe, came the point where blondes diversified. On the one hand there were glacial blondes, the ice-maidens, personified by Grace Kelly and Tippi Hedren, and on the other were the bombshells, epitomised by Monroe and Jayne Mansfield.

Natural or fake, cool or hot, airhead or icon, saint or sinner. Whichever of these two blonde stereotypes prevailed, both ultimately proved the epithet that blondes have more fun.

Hitchcock Blondes the ice queens

'*Hitchcock, with his blondes, captures all my mystical feelings about women.*'

Camille Paglia - Salon Magazine

It is well known that the 'master of suspense' film director Alfred Hitchcock was obsessed with blondes and only cast them in his movies. But Hitchcock blondes were Hollywood blondes with a difference. They were ice-icons of the era, women to be put on pedestals, goddesses of celluloid, their untouchable quality mirroring Hitchcock's pathetic unrequited desire. Though the relationships with his stars off-screen were not the stuff of his fantasies, their professional collaboration resulted in a series of memorable, mystical performances. His obsession for blondes was particularly lucky for Kim Novak in the late Fifties as Columbia was desperate for a new alternative to Marilyn Monroe and Rita Hayworth, both of whom had become somewhat flaky and unpredictable. Novak was packaged, peroxided and promoted and consequently landed the lead role as the lonely Judy in Hitchcock's *Vertigo*. Ironically she was not his first choice although it led to the best performance of her career. Hitchcock had wanted to cast the imperious and icy Vera Miles but when she became pregnant and turned down the role he settled for Novak. Luckily her platinum hair was intrinsic to the role since the hero (James Stewart playing Scottie) famously persuades her to go blonde and be made over by him to look more like Madeleine, his supposedly lost love. The whole charade is carried a stage further when he makes her pin it up in a certain way until she has finally metamorphosed into his perfect woman.

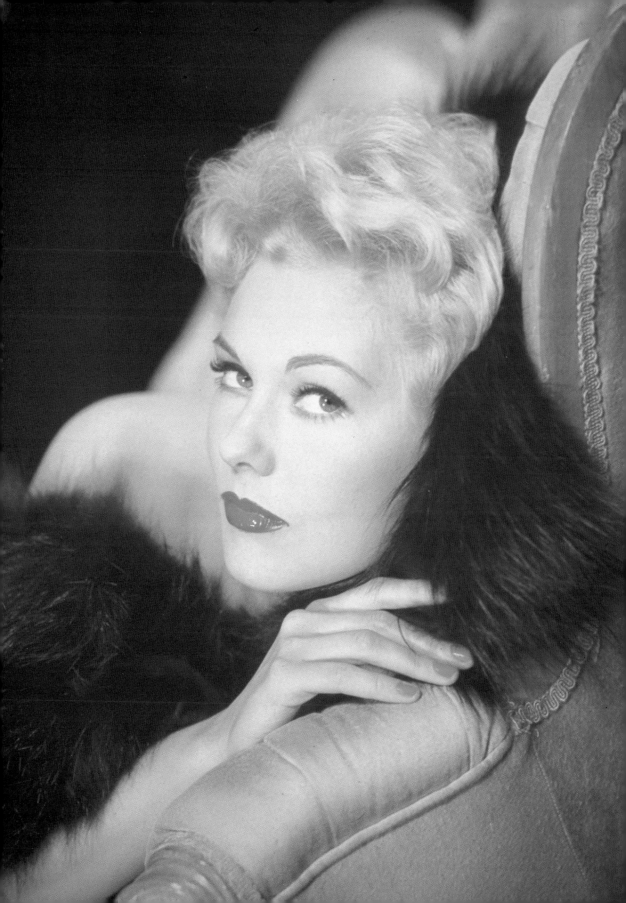

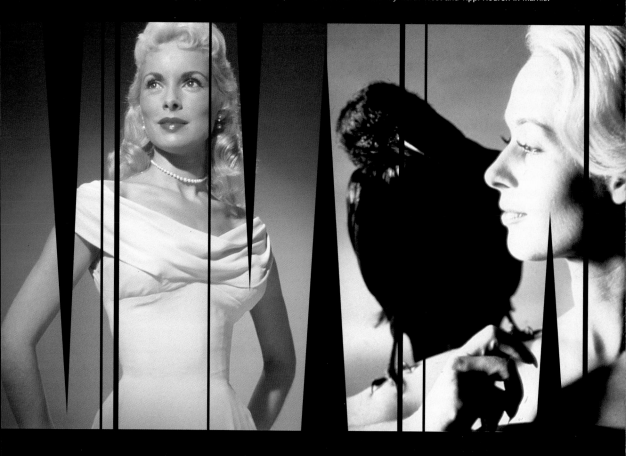

Other blondes in the Hitchcock firmament include Eve Marie Saint (*North by North West*), Joan Fontaine (*Suspicion*), Carol Lombard (*Mr and Mrs Smith*) and Janet Leigh who was so shockingly stabbed in the shower in *Psycho*. Grace Kelly (*Dial M for Murder*, *Rear Window* and *To Catch a Thief*), with whom he fell in love and who allegedly indulged some of his sadder fantasies, epitomised the virginal blonde as untouchable ice-goddess more than perhaps any other. Camille Paglia, in a recent book on Hitchcock nominates ex-fashion model Tippi Hedren as the ultimate Hitchcock heroine. She was his last obsession and starred unforgettably in both *The Birds* and *Marnie*. Tied to Hitchcock's whims in more ways than one, she first signed a seven-year contract as well as unwisely agreeing to a clause which led to her being tied down while live birds pecked at her. One bird did its best to claw out her left eye leaving her scarred both literally and emotionally. Ultimately she had a breakdown.

'Hitchcock's virginal blonde goddesses remain among the most potent icons of our era', says Camille Paglia in her book about Hitchcock. No artistic relationship in our times is quite as awe-inspiring as that of Hitchcock with his blondes. Paglia says 'he captures all my mystical feeling about women'.

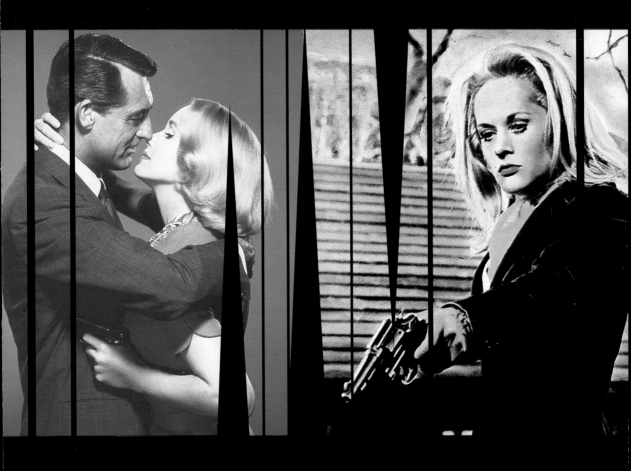

But has the Hitchcock blonde fallen from her pedestal since his demise? Can any remake of his films, like the recent version of *Dial M for Murder*, starring Gwyneth Paltrow, in any way live up to the extreme subtlety and brilliance of the original, with its remote and haunting performance by Grace Kelly? The very idea is depressing to the purist. *Some critics see Hitchcock's adulation of the blonde as reverence, his vision of them as flawless and angelic proof that men are weak and inadequate. But there is also evidence of misogyny, brutality and voyeurism* (he was said to get sexual gratification watching his blonde stars through telescopic lenses) and his films became more and more obsessed with punishing women in the most graphic ways for the uncontrollable effects they had on men. He did once attempt to entice a brunette into a starring role. This was Audrey Hepburn in 1959. She turned him down, refusing to work with him because of a particularly nasty rape scene proposed in the film *No Bail for the Judge*. Perhaps the real reason she said 'no' was because he came at her with the bleach?

BOND
BLONDES
IN 1962 URSULA ANDRESS PLAYED THE FIRST BOND BLONDE IN DR NO, AND CARVED HERSELF THE ROLE OF ICON AS SHE STALKED UP THE BEACH LOOKING FOR CONCH.
'ARE YOU LOOKING FOR SHELLS?' SHE ASKS BOND. **'NO,'** HE REPLIES, **'I'M JUST LOOKING...'**

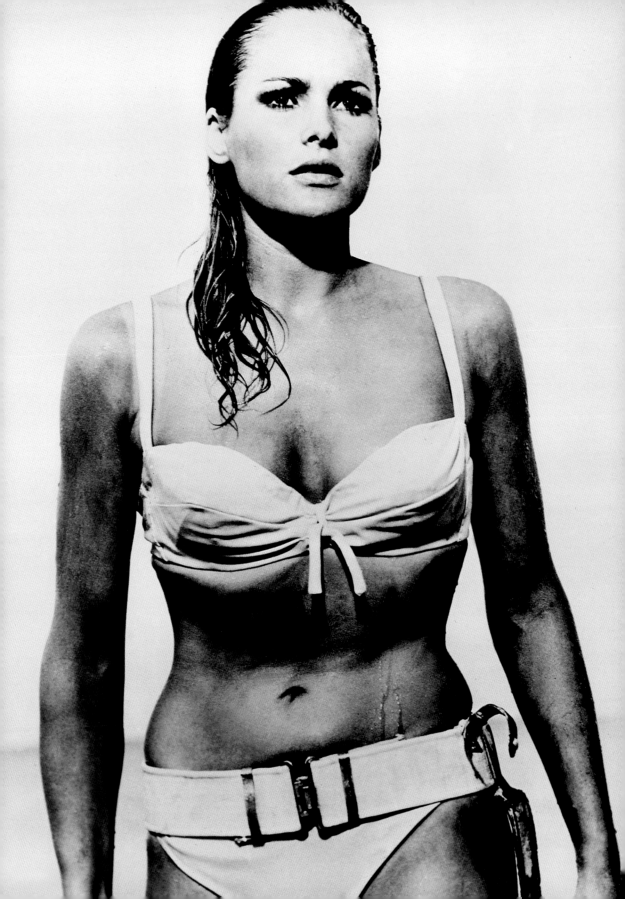

Before this moment, both on celluloid and in real life, dream girls simpered and minced around on pinpoint stilettos with pointy bras and big skirts. The Fifties heroine was an altogether different proposition at a time of sexual repression. Her waist was cinched in, her face was painted and her hair was permed. She was visually as uptight as the morality of the moment. Suddenly, ten years on, here was an athletic body, square-shouldered and barefooted. Here was the forerunner to the gym-toned body – muscular woman not material girl. A natural, wet-haired, un-made-up woman, rather than a pampered pet. Andress appeared onscreen as Honey Ryder, the year of Marilyn's suicide, and in one languid walk up the beach she redefined sex appeal and body-shape for the future. In her pure white power bikini, her only accessories a knife on her hip and a healthy tan, she set the tone for Bond Girls and stereotyped male fantasies for many years to come. Pre-dating the Gladiators by two decades, she was blonde, she was buxom, she was sexy and she was strong and yet she was still all too vulnerable to seduction.

AFTER URSULA, CAME A BEVY OF BLONDE BEAUTIES FOR BOND TO DEVOUR...

Shirley Eaton in *Goldfinger*, Lynn-Holly Johnson in *For Your Eyes Only*, Britt Ekland in *The Man with the Golden Gun*, Honor Blackman as Pussy Galore in *Goldfinger*.

Cubby Broccoli knew a winning formula when he saw one and 007's next blonde, Daniela Bianchi, played the archetypal Russian spy to Connery's increasingly laconic Bond. Many memorable blondes followed, including Shirley Eaton, asphyxiated by gold paint and Honor Blackman who made her mark as the leather clad Pussy Galore in *Goldfinger* in 1964; Molly Peters in *Thunderball* and Catherina von Schell in *On Her Majesty's Secret Service*, the only Bond film starring George Lazenby as the smooth-talking secret service agent. Many of these Bond Blondes met a grisly fate after or even during a torrid night with our all-time favourite secret agent.

Roger Moore was supplied with the platinum executive secretarial services of Britt Ekland in *The Man with the Golden Gun* in 1974 and the films that followed featured a number of forgettable blondes in films like *Moonraker* (1979), *For Your Eyes Only* (1981), and *Octopussy* (1983). Many actresses never made it big after their roles as Bond Blondes and disappeared into obscurity. However, in *Never Say Never Again*, Sean Connery came back to star with Kim Basinger as Domino, a blonde who survived the curse of being a Bond girl and went on to do better things. Fiona Fullerton who played Pola in *A View To A Kill* had a view to a new career and is now doing rather better as a writer than she did on screen.

Maryam d'Abo in *The Living Daylights* and Kim Basinger in *Never Say Never Again*.

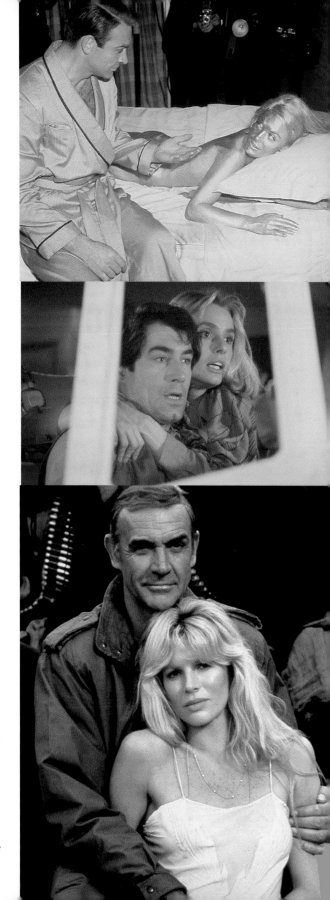

Daniela Bianchi in from *Russia With Love.*

Timothy Dalton got Maryam D'Abo in 1987 in his first Bond film, *The Living Daylights* while Pierce Brosnan's love interest in *Tomorrow Never Dies*, Cecile Thomsen, was the genuine Scandinavian article. As the first Danish Bond girl, she got the part as an unlikely Oxford PhD, Professor Inge Bergstrom in the 1997 Bond movie, only after (surprise, surprise) she agreed to do a nude scene.

THERE IS ALWAYS A NEW BOND FILM IN THE PRODUCTION LINE, BUT THE **TYPICAL** BOND HEROINE NOW CONFORMS TO A **MODERN** STEREOTYPE. SHE IS A MORE **INDIVIDUAL**, MORE **EMANCIPATED** CHARACTER THAN SHE WAS THIRTY YEARS AGO. TODAY'S BOND GIRL HAS **BRAINS, BRAWN, WIT** AND THE **DISCRIMINATION** NOT TO FALL **INEVITABLY** FOR 007'S **CHARM**. AND THESE DAYS SHE IS JUST AS LIKELY TO TURN OUT AS A REDHEAD OR A BRUNETTE.

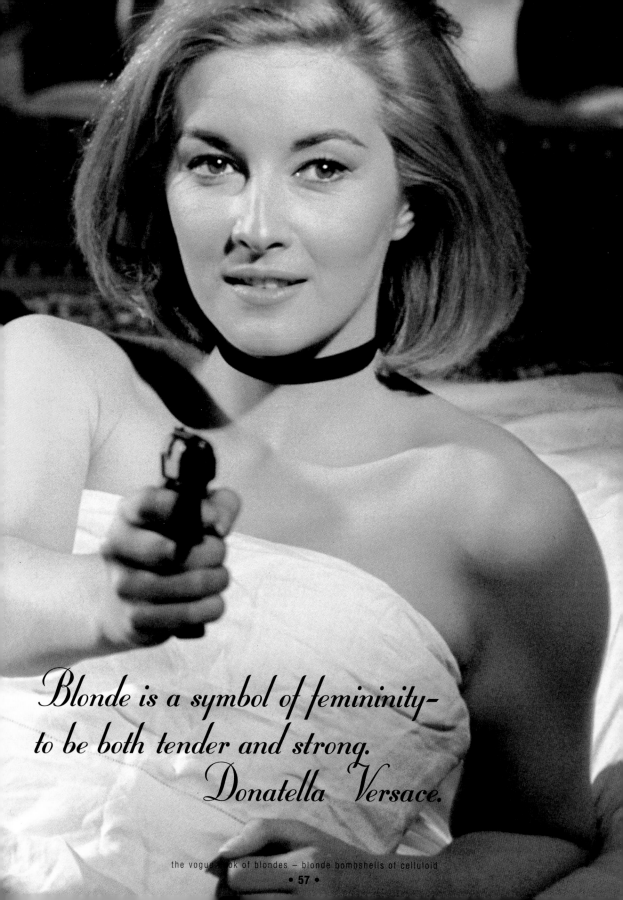

Blonde is a symbol of femininity –
to be both tender and strong.
Donatella Versace.

Cult films in the Sixties starred a host of kittenish blondes - Catherine Deneuve, Julie Christie and the incomparable Brigitte Bardot.

the sex kittens

pure gold on the silver screen

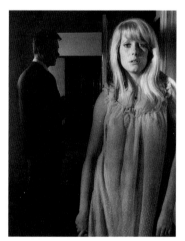

In the Sixties, British Vogue called Brigitte Bardot 'the sensuous idol, a potent mixture of the sexy and the babyish, a seething milky bosom below a childish pout'. Suddenly the brassy, pneumatic blonde of Fifties America, epitomised by Marilyn, was less appealing than the slightly scruffy insouciance of Bardot and the St Tropez beach crowd. The phrase 'sex kitten' was coined to describe her and the decade began with a passion for all things European, including foreign films by a *nouvelle vague* of

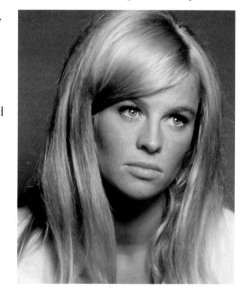

directors like Chabrol, Fellini, Godard, Truffaut and Malle. The 'Swinging Sixties' crowd who first discovered voluptuous blondes like Anita Ekberg and Capucine, now admired Catherine Deneuve, in cult films like *Repulsion* and *Les Sauvages*. Other favourites were Britain's Julie Christie who starred in *Billy Liar* and then became stellar in *Darling*, *Dr Zhivago* and *Far From the Madding Crowd*, Candice Bergen in *The Group* and Roman Polanski's ill-fated wife, Sharon Tate.

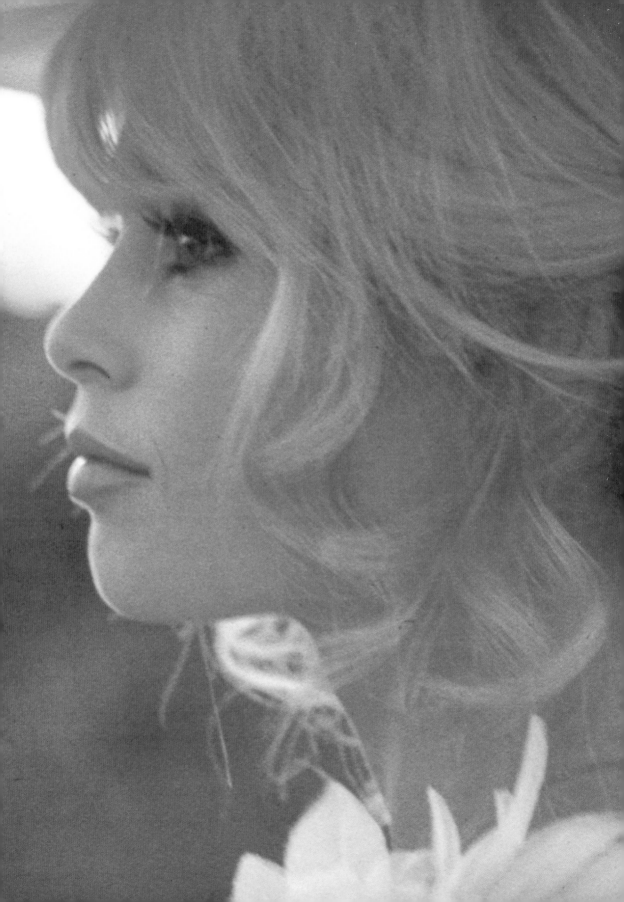

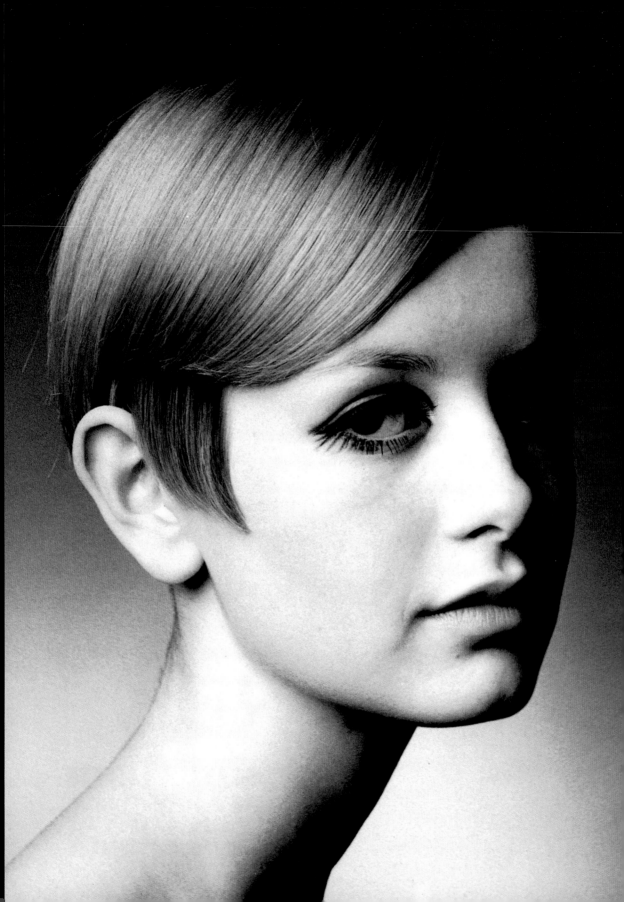

The word 'sexy' became a new and favourite adjective. Britain's other famous blonde, Biba, otherwise known as Barbara Hulanicki, opened her fashion boutique in Kensington causing queues as long and as passionate for her clothes as the audiences for the cult foreign films and the rock concerts of the Rolling Stones and The Beatles. This was the era of the BIBA girl with her smokey eyes, pale lips and feather boas. The same girl was also wearing Britain's most popular export of the decade – Mary Quant's mini skirt. She was taking the pill and the two most frequently used words in her vocabulary were 'freedom' and 'love'. Rock girlfriends like Patti Boyd, Marianne Faithfull and Anita Pallenberg all wore their hair blatantly blonde, long and straight, their huge false eyelashes peeking out from behind heavy fringes. They became as fêted as film stars, indeed sometimes even appearing in films in cameo roles and mostly playing themselves.

In Britain in 1966, Twiggy was voted Woman of the Year. The same height as Kate Moss but at least a stone lighter (both girls at five foot six being historically too small for catwalk modelling), Twiggy was flat-chested and stick-legged, her large dark eyes underlined with pencilled lashes. Her little-boy haircut, shaped by Leonard and coloured by Daniel Galvin became a look that was copied globally. Unquestionably the world's first supermodel, her image was plastered over walls, magazine pages and television screens all over the world.

'I remember when her boyfriend, Justin de Villeneuve, brought her in to the salon,' says Daniel Galvin, 'she'd been using some home colourant and her hair was ginger.' Galvin corrected Twiggy's hair which Leonard chopped to about three-quarters of an inch all over. It took him five hours to add literally thousands of tiny blonde strip highlights. Later, when he was officially flown out on location while she was filming *The Boyfriend*, Galvin had to tint her parting religiously every 10 days. The Seventies gave us a new take on sex kittens after Twiggy's androgynous looks paved the way. The power of the film star was challenged by icons on smaller screens. TV heroines and rock singers on video had as much impact on a global audience ever hungry for a new look as those who previously set trends on celluloid.

Jane Fonda

Seventies babes

didn't smoulder and pout and run around with playboys: they were sexy in an altogether more independent way. Rather like Bond Girls, they looked easy – but this was the time of women's liberation and the image was deceptive. Germaine Greer had written *The Female Eunuch*, Jane Fonda had chosen to get involved in politics with her anti-Vietnam campaigning, while women were encouraged to **burn their bras** and not be subservient to men. As if by osmosis, the archetypal blonde in film and TV roles gradually acquired more spunk.

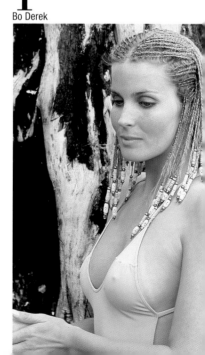
Bo Derek

She also shored up her personal bank balance, ensuring that she got a percentage from the films she appeared in or used a pivotal role as a spin-off for marketing. Bo Derek, the perfect '10', and Farrah Fawcett Majors were two of the most obvious. Both stars had Hair Power, their hairstyles hitting headlines on a worldwide scale. Farrah Fawcett Majors' multi-layered, highlighted, lioness-like blonde mane for *Charlie's Angels* was copied by would-be Angels everywhere just as Bo Derek with her Caribbean-style braided hair acquired a cult following. While ostensibly appearing empty-headed, both stars made a great deal of money for themselves.

The Seventies show *Charlie's Angels* gained a huge following but, according to statistics, it was the blonde angel who was the most admired.

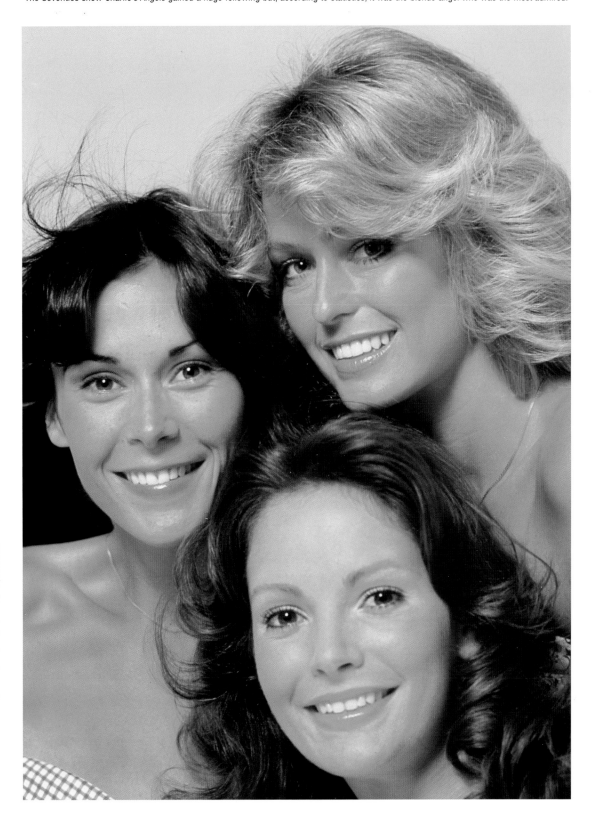

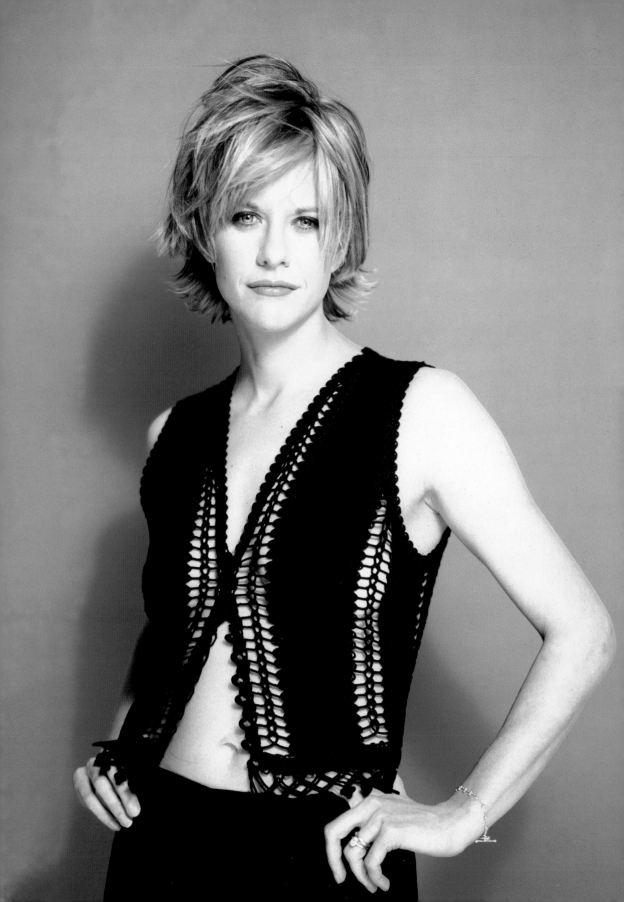

THE LIGHT BRIGADE
today's luminaries

'I make everyone blonde **or blonder.**'
Sally Hershberger

Hair trends are set in different ways. Sometimes from the catwalk, sometimes from a pop video and more often than not from a current hit movie. 'Hollywood women like to be blonde,' says hairdresser Peter Savic, as each era spawns a new crop of trend-setting bombshells. Currently it's Meg, Michelle, Gwyneth and Cameron whose every comb-out results in a ricochet effect at the hairdressers.

In When Harry Met Sally, Sleepless in Seattle Addicted to Love, City of Angels and You've Got Mail, **Meg Ryan** had fans arriving at salons the world over, clutching the publicity pictures and wanting both the cut and the colour.

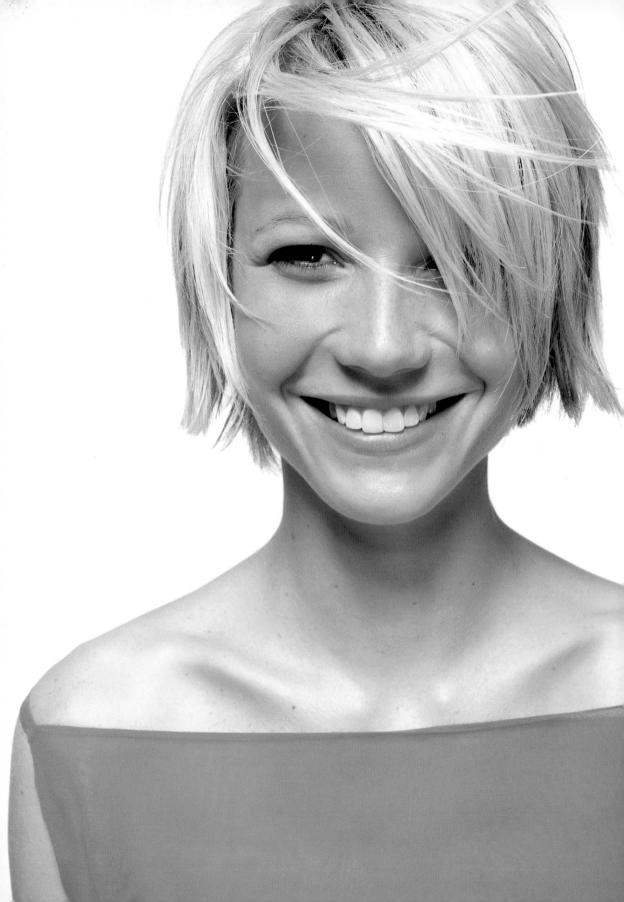

Gwyneth Paltrow with extensions in *Shakespeare in Love*, or dead straight in *Sliding Doors* caused much the same reaction. Cameron Diaz adding a hairclip to her short bob in *Something About Mary*, Geena Davis, cropped to chin-length and white blonde in *The Long Kiss Goodnight* or Kristin Scott Thomas's surprising vanilla shade for *The English Patient*;

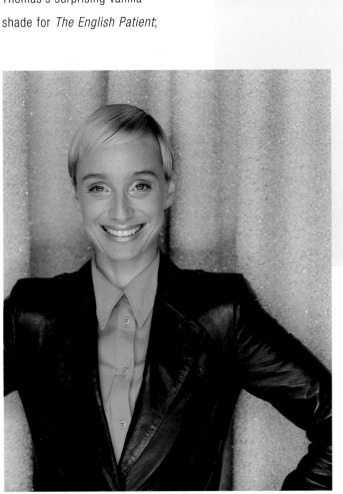

all of these were the **looks** (and **locks**) we wanted to copy.

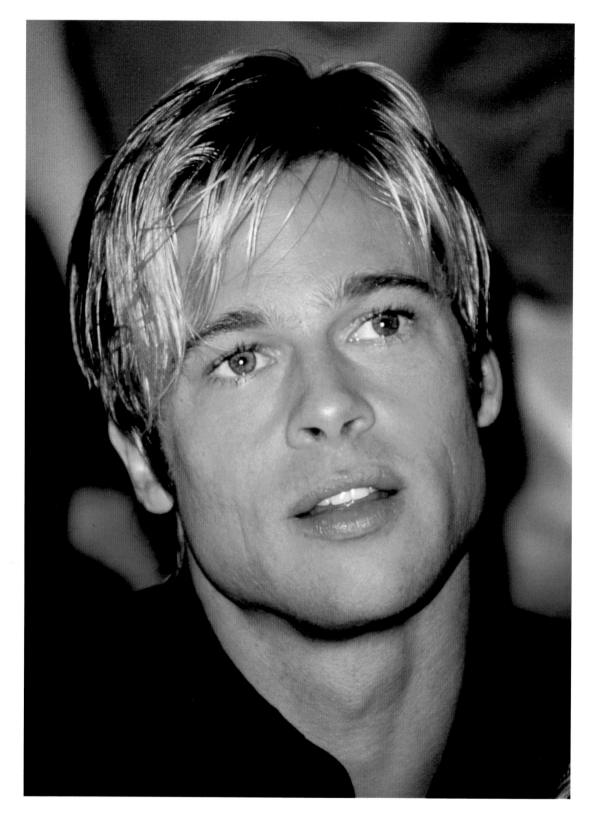

Boys set trends too.
Tom Cruise's sharp,
short back and sides
and sun-kissed tips
in Mission Impossible,
Brad Pitt's
ultra-blondeness
in Meet Joe Black,
and Bruce Willis as a skinhead
turned golden in The Fifth Element
– they all caused a riot
at the hairdressers.

With any new film, a colour and cut cult could be in the making just as soon as the cinematographers adjust their focus and spotlight the stars. Seventy years ago, photography suffered not only from poor techniques but also from the limitations of the medium itself. The film used was orthochromatic. It did not register colours correctly and was completely insensitive to red. Mouths came out black and light was crude, flat and unimaginative. Lights were placed directly in front of the subject and very little was done to contour the body with light or model facial structure. Outside, the look and tone of hair in films was impossible to control. Inside (where the spotlights themselves are still referred to as 'blondes' and 'redheads' by those in the trade), cameramen had to work hard to achieve the right results with the unsubtle peroxided hair and heavy make-up on stars like Jean Harlow.

Unlike today, Jean Harlow's look was created despite the parts she played and often the lighting team's only direction was to make the star look beautiful no matter what. Max Factor was simply told to 'effect an alteration in her appearance that would make her nationally known and talked about overnight'. These days the whole process of image-making is more subtle. The camera work establishes a distinctly personal look to the film as a whole and the star or stars are not necessarily the focus. When it comes

to the leading roles, the stars have to look appropriate for the role and yet be in sync with global film and fashion worlds instantly. A new form of stylist has evolved to achieve this, someone who comes in from outside and has an overview. Sally Hershberger is the perfect example of a top talent who can move between the film set, the fashion studio and the personal jets of private clients working her magic both on and off celluloid. Hershberger is brought in to films by the director to advise on just how to make the star look good on film (however complicated the lighting), and then to make it happen. Her expertise is valuable simply because she can cross from one medium to the other and come up with the appropriate image for a star. Hershberger's success is consolidated in her partnerships with powerful women in the media and in her friendships with the stars themselves. Her clients include Tom Cruise and Nicole Kidman, Michelle Pfeiffer, Brad Pitt, Hillary Clinton and, of course, Meg Ryan. She has particularly been championed by writer and film producer Nora Ephron who uses her for films and by Annie Liebowitz who worked with her on her legendary portfolios of portraits for the American magazine, *Vanity Fair*. 'She makes the stars feel safe,' says Ephron. 'She is not just a hairdresser but concerned with the whole image, an intelligent and smart human being who happens to be one of the best cutters in the world. She can listen to the film maker explaining who a character is and come out with someone everyone is happy with. Take Meg's film *You've Got Mail*. It's not an easy thing to find a hairstyle that looks contemporary without looking styled. Sally just came in and nailed it.'

Neve Campbell and Milla Jovovich, both chestnut beauties, were recently steered towards Paris colourist Christophe Robin who made their hair lighter for upcoming movies. Lisa Kudrow lost at least six inches of hair and got blonder for her film role as a newscaster in *Analyze This*. 'Actresses don't always like the lighting on films currently,' explains Hershberger, 'because it is more real that it has ever been before. Sometimes these days, the lighting can be very dark, really quite edgy and the hair needs to show. The lighter you go the more photogenic you become.'

With stars like Pitt, Ryan
and Pfeiffer, it's hard to
know where Sally's styling
has led them and where
real life as
a blonde
begins.

BOY BLONDS

'David Hemmings was my first blond for films. I bleached him for the film **Blow Up.** Then I made **Richard Burton** silver white and then **Nigel Havers** blonde for **Chariots of Fire.'**

Jo Hansford, colourist

A hairdresser can change your life. Or in the case of David Hockney an advertisement for hair colour can be the catharsis. The first famous advertising slogan for hair colour, 'Does she or doesn't she?' was created for Clairol by a junior copywriter, Shirley Polykoff, at the agency Foote, Cone and Belding in 1956. It ran for fifteen years.

'If I live only one life, let me live it as a blonde', another of Polykoff's memorable slogans, was the line that caught Hockney's eye and the Clairol hair he acquired in a New Jersey sink became and still is his trademark. Hockney's 'Blondes have more fun' philosophy (garnered from Clairol's 'Is it true blondes have more fun?' campaign in the early Sixties) was not taken up as a mainstream look for men until much later.

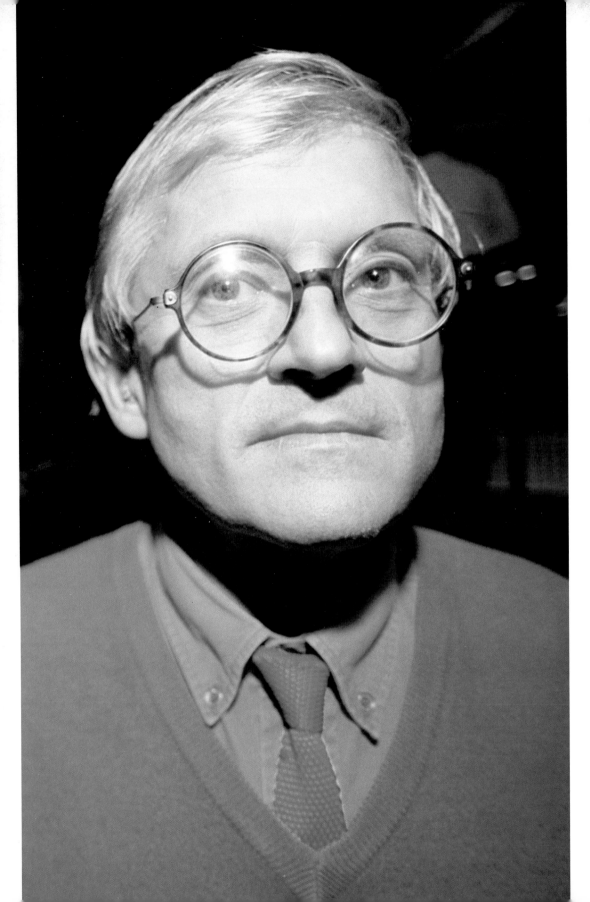

After all it's women who are characterised as the 'fairer sex' and few adult males in the past have consciously chosen to become blonder. Psychologists say that blondeness signals subordination as well as being associated with youth, innocence and naivety and these attributes are not obviously desirable for the would-be macho male.

Even as far back as the fifth century AD it was considered effeminate for boys to have long hair so they cut it off and dedicated it to the gods. Your average Greek god, whose hair is drawn on Greek pottery, generally had an abundance of dark curls and was only portrayed with fair hair on occasion. It must have been pretty rare and therefore noteworthy.

Of course hair has always been associated with virility (Samson's loss of it becomes his downfall) and never more so than in the time of the Cavaliers in Britain and at the sexually liberated French court of Louis XIV where luxuriant locks were the ultimate status symbol. The fashion for abundant hair and its implications of sexual prowess, may well have been the reason why the full-bottomed wig became a focal point of masculine attire. It was worn at all times (even in battle) and considered absolutely essential for upper class males throughout Western Europe. It was a fashion that lasted nearly a hundred years and might have lasted even longer but for the French Revolution, where the guillotine rid aristocrats of their heads both literally and symbolically.

Louis XIV resorted to wigs;
indeed, at one time he had as
many as 40 wig makers, to
disguise his thinning hair as he
got older. He was also called
The Sun King (Le Roi Soleil)
but this was no reference to the
colour of his hair – the
elaborate hairdressing, plaiting,
teasing, ribboning and
powdering of styles being a
more important consideration
than the colour.

Boys who blatantly dye their
hair are a modern
phenomenon. Therapists
would say that modern men
are more in touch with their
feminine side and certainly
those who try it are as proud

to be fake as were the modish males of the eighteenth century, flaunting their artificial
tresses in intricately coiffed and powdered periwigs. It wasn't until very recently that
male heroes changed their stereotyping. Up until the Sixties, male sex symbols were
by definition tall, dark and handsome. Swashbuckling pirates, glamorous bullfighters,
Victorian heroes, Cavaliers and even Hells Angels bikers were automatically all dark in
the collective imagination.

Jane Austen's Darcy could never have been blond, nor could Margaret Mitchell's, Rhett Butler
in *Gone With the Wind*. Heroes, both in film and fiction were endlessly drawn as square-jawed
and rugged, with wild hair, beards and moustaches, the archetypes of society's perceived ideas
of masculinity.

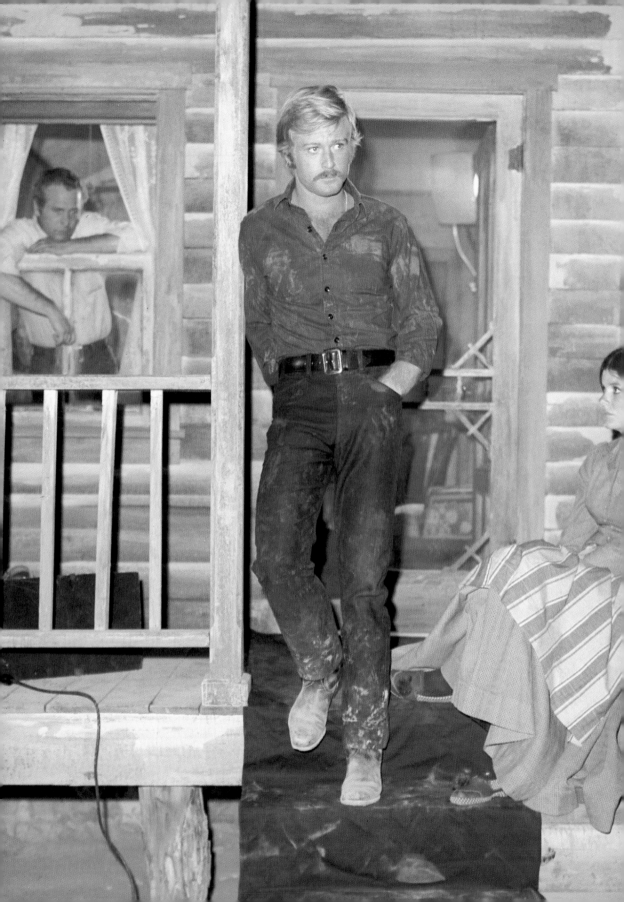

Now that masculinity isn't an issue, boys today reach for the bleach as often as any girl.

In fact in practical terms the very shortness of their crops being the most suitable for drastic bleaching. When did we start to fall for baby-faced blonds? It wasn't until Robert Redford and Paul Newman got together in *Butch Cassidy and the Sundance Kid*, Peter O'Toole went blonder in the desert sun for *Lawrence of Arabia*, Terence Stamp was startlingly blond in *Billy Budd* and Björn Andresen was just plain beautiful in *Death in Venice*, that blond men acquired allure and desirability.

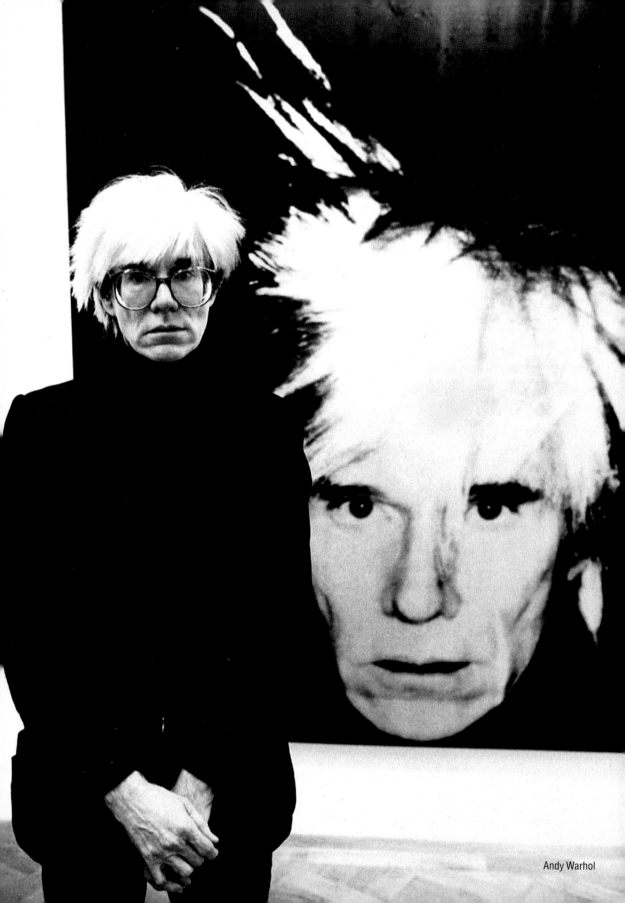

Andy Warhol

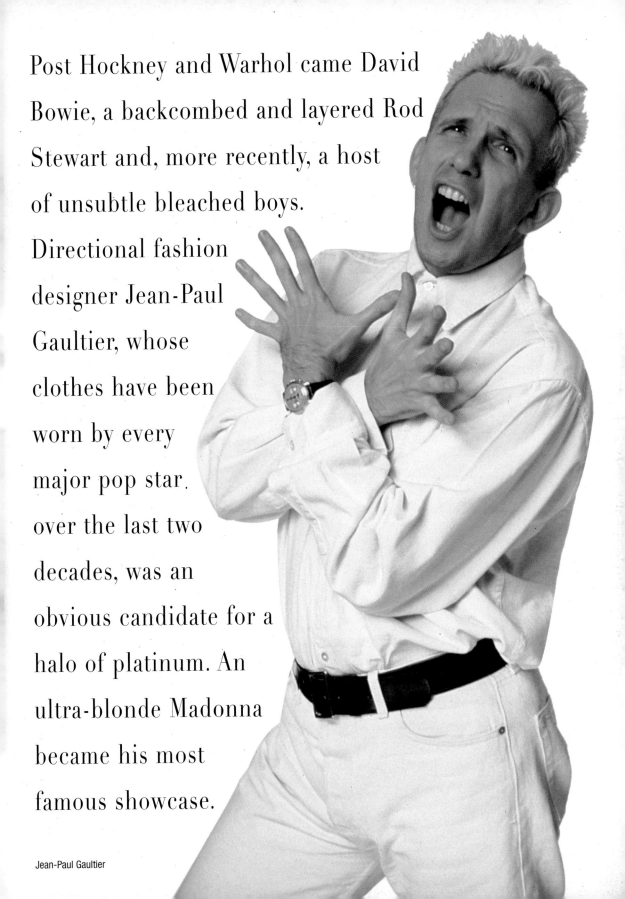

Post Hockney and Warhol came David Bowie, a backcombed and layered Rod Stewart and, more recently, a host of unsubtle bleached boys. Directional fashion designer Jean-Paul Gaultier, whose clothes have been worn by every major pop star over the last two decades, was an obvious candidate for a halo of platinum. An ultra-blonde Madonna became his most famous showcase.

Jean-Paul Gaultier

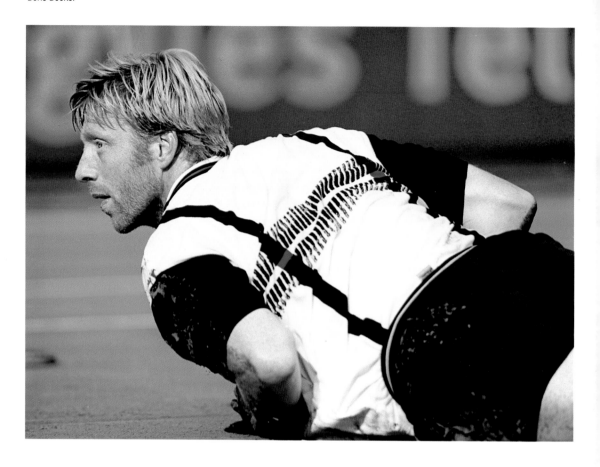

It's not only stage performers who have style. Natural blond athletes like Jurgen Klinsman, Bjorn Borg, Denis Bergkamp, Michael Owen and Boris Becker score points for the way they look as well as for the way they play.

David Beckham

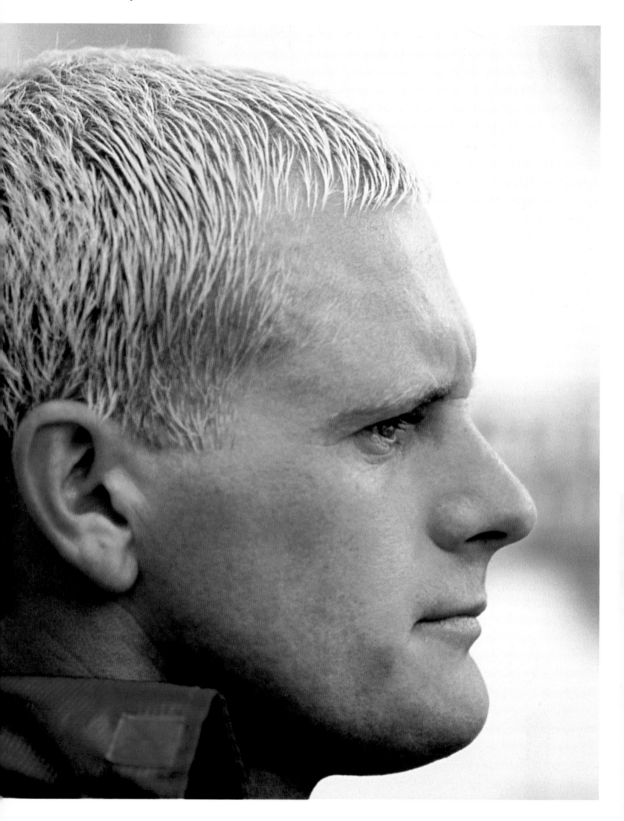

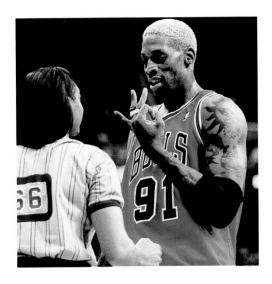

Historically the golden boys of football, while falling for permed hair and gold jewellery as accessories, were never bottle blond. It was **Paul Gascoigne** (Gazza) who set the trend and **Ian Wright, David Beckham** and latterly the **entire Romanian football team** during the World Cup followed his example, not to mention a **squad of international athletes** headed by **Denis Rodman** who have all since **succumbed to the bleach.**

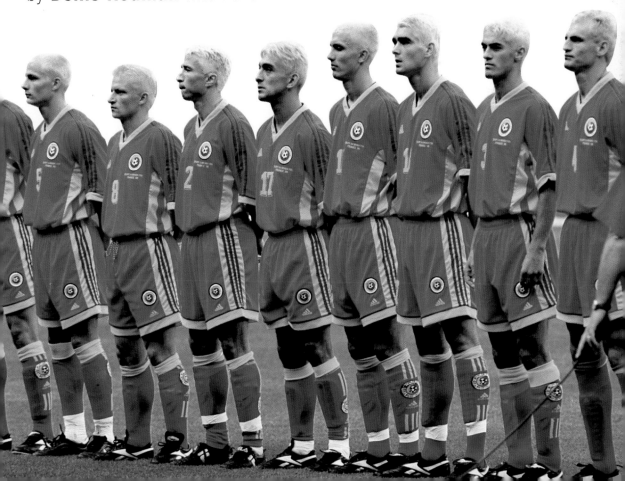

Cult contemporary blonds include **Johnny Lee Miller,** *Trainspotting's* Sick Boy, posthumous pop hero **Kurt Cobain** and *Die Hard* star, **Bruce Willis** Fans swoon for fair-haired **Brad Pitt** as he was in *Seven Years in Tibet* and an even blonder vision contrived for his role in *Meet Joe Black.* **British thespian, Kenneth Branagh** was transformed in the hairdressing salon for his interpretation of the **Prince of Denmark** and a rather more flaxen-haired than usual **Ralph Fiennes** scored high in the swoon factor as the lead in *The English Patient.*

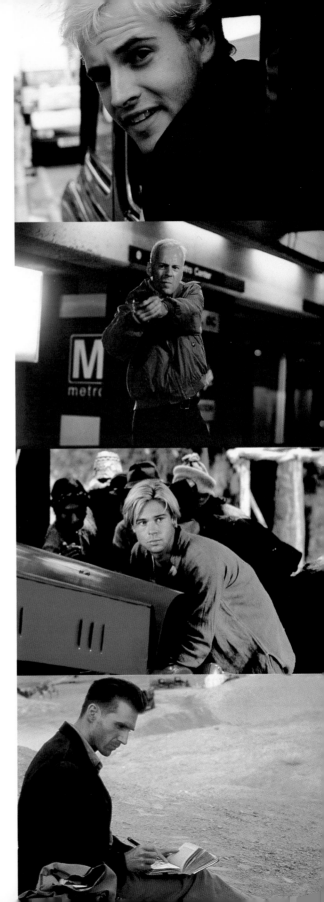

Then, of course,
there's über-boy blond,
Leonardo DiCaprio
- child-like, cherub-faced, honey-haired
and irresistible.

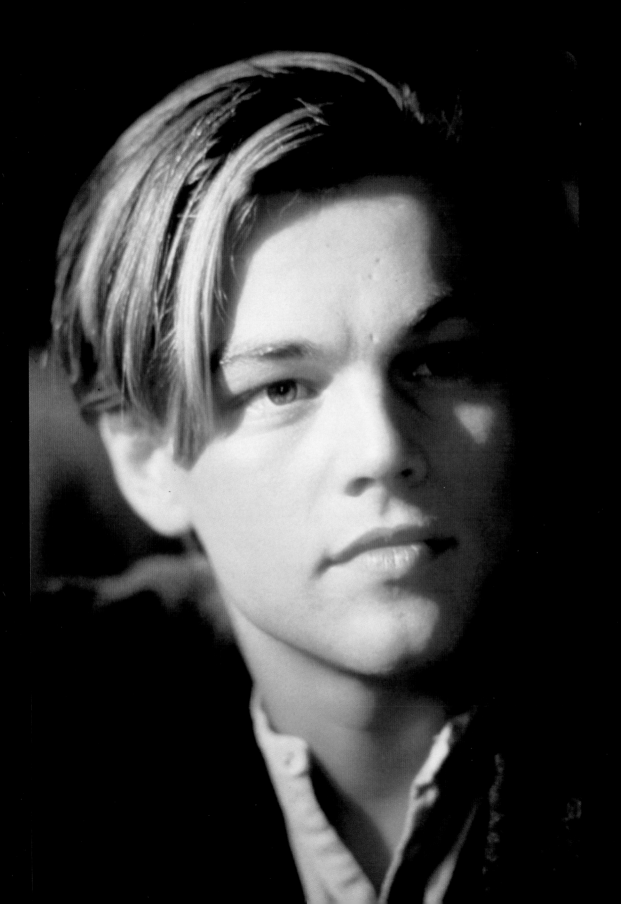

BLONDE
AMBITION

'Like any star, her hair is a trademark of sorts. Nowadays her look is more minimalist - before her image was louder. Before this darker quieter phase, she used other women as reference, now she's exploring her own style, she has more confidence.'

Luigi Murenu on Madonna

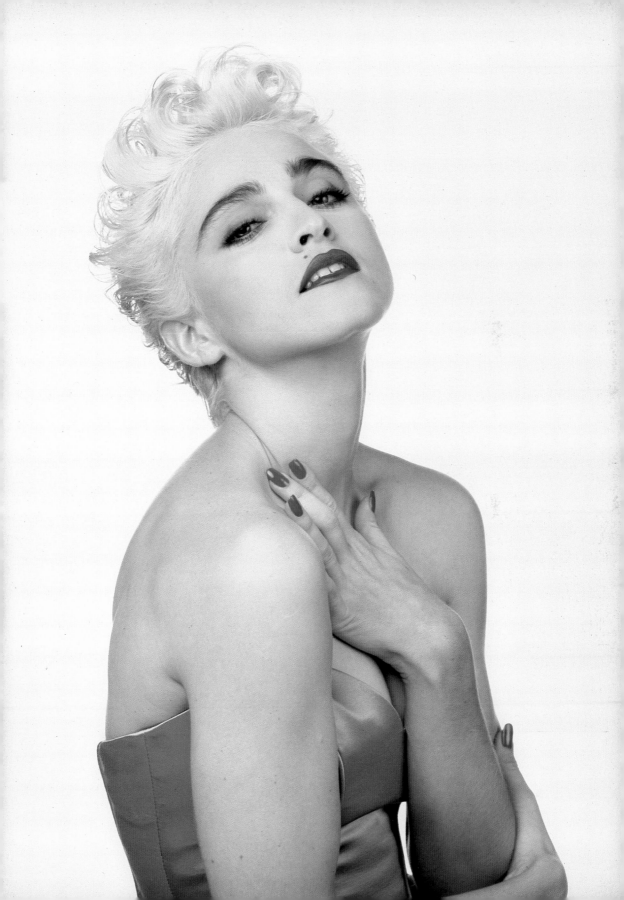

THE FACE

DESTROY!

ANARCHY IN
THE EIGHTIES

KURTIS BLOW
B-BOYS RALLY

BURCHILL
ON LADS

HISTORY OF
THE FUTURE

Pet Shop Boys

Adam Faith

The Waterboys

Jan Fabre

Saigon in Essex!

The model for this cover shoot turned up at the studio with black hair, which was promptly bleached for this seminal Nick Knight cover.

ROCK STARS HAVE ALWAYS FELT IT IMPERATIVE TO ADMINISTER AS MANY SEXUAL, SOCIAL AND CULTURAL SHOCKS AS POSSIBLE. WITH THEIR MUSIC, APPEARANCE AND BEHAVIOUR THEY CAN REARRANGE THE WORLD THROUGH THE MEDIUM OF THE YOUNG. THE MUSIC IS THE MESSAGE BUT THE VISUAL IMAGE SINGS OUT LOUD AND CLEAR.

played the seminal blonde who just sat around and looked beautiful. Debbie Harry of Blondie, and later Madonna, decided to carve out a different niche for themselves on planet pop. Both created a peroxide persona for themselves that was anything but passive. The highest unemployment since the depression of the Thirties gave rise to punk in the Seventies and to the art of the subversive. Nothing at the time was as subversive as hair dyed blatantly and badly to make a fashion statement.
The Metal/Punk group Nirvana even called its first album Bleach – an ode to the dye-hard habits of its high profile singer Kurt Cobain.

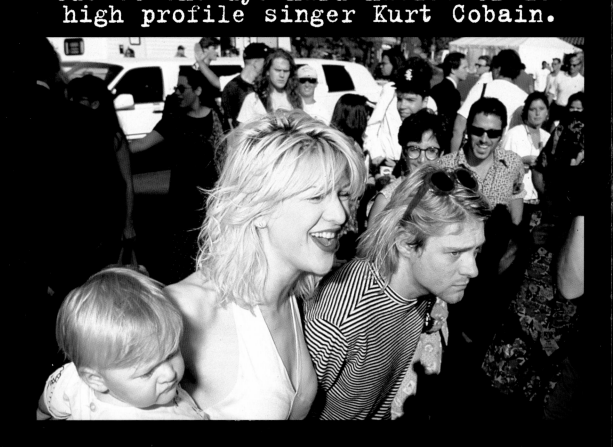

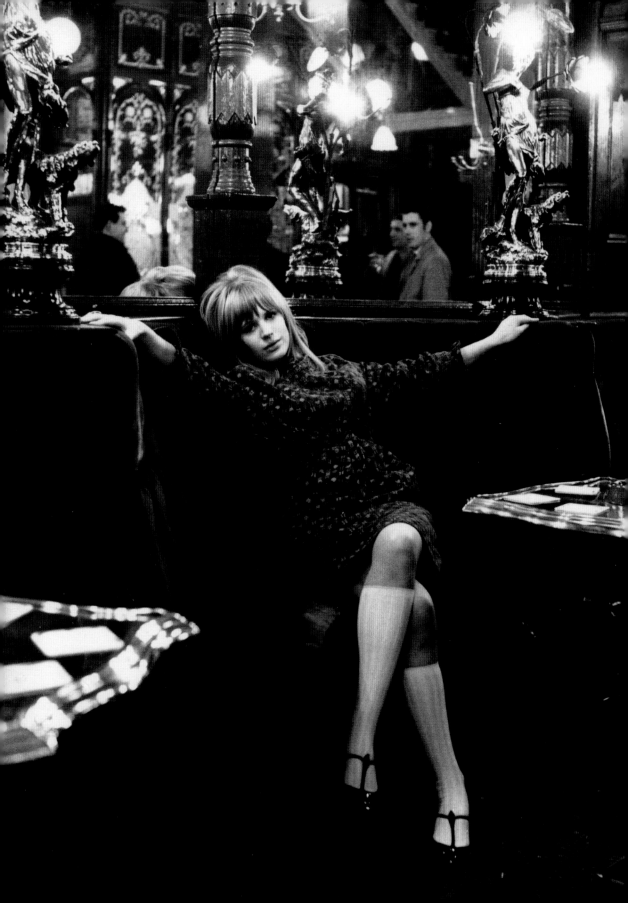

DEBBIE HARRY STARTED BLEACHING HER HAIR IN THE EIGHTH GRADE. SHE DID A FEW STREAKS HERE AND THERE AND THEN SHE LET THE ROOTS GROW OUT AT THE BACK BECAUSE SHE THOUGHT IT LOOKED COOL THAT WAY.

In any case, it was good for showbiz and good for marketing. Before Blondie had their first hit single in 1976, Debbie Harry, Blondie herself, had been learning about beauty during her stint in Kansas City, as a Playboy Bunny. She benefited obliquely from the very strict dress, hair and make-up code important for her chosen look as 'all-American bunny'. A bunny had to wear the right shade of lipstick and was told where to put the blush and how to apply false eyelashes; skills she used and abused later for her cult image as leader of the band. Blondie sold more than 40 million albums in the Seventies and came back, blonde as ever, to make a number one hit in the late Nineties.

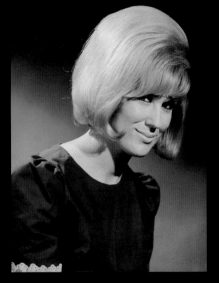

Dusty Springfield

In the Eighties British fashion meant pop videos on MTV and Di and Fergie cover stories. British style was dubbed 'Rock 'n' Royalty' by *Vogue* who were now photographing Madonna, Prince, Billy Idol and Michael Jackson on their fashion pages in place of film stars. If Blondie was out of sight in the Eighties, her cult status was replaced by

the New Blonde on the Block.

Madonna named her 1990 tour Blonde Ambition to suit her peroxide image. She wore crucifixes and sex shop corsets and set out to flaunt her sexuality, have fun and in doing so she has, to date, sold in excess of 100 million albums worldwide. But she didn't just confine her platinum styles to the stage and video. As versatile as she is talented, she also appeared in films. As Breathless Mohoney for the movie *Dick Tracy* and later playing Eva Peron in *Evita*, she easily adopted whatever blonde personality the roles demanded. Other prominent pop icons, like Dusty Springfield with her candyfloss bouffant or Marianne Faithfull with her honey-coloured fringe, have stuck with one look throughout their careers. Not so Madonna who plays with a new image for every phase in her life. These days (though who knows for how long?) she chooses to be dark.

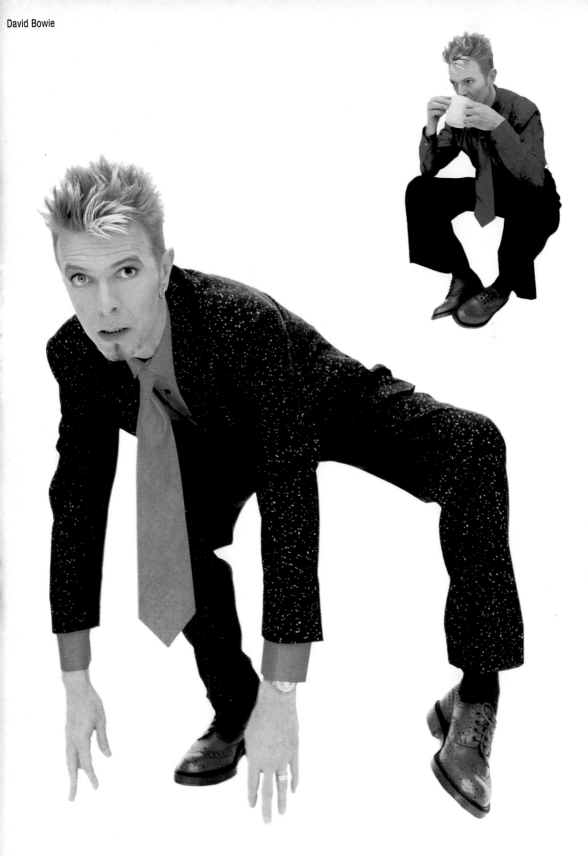

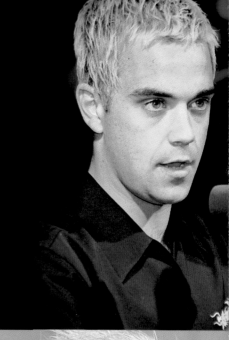

THE FIRST POP BLONDES WERE BOYS. **ROD STEWART** HAD HIS PEROXIDE SHAG AND WHILE **DAVID BOWIE** EXPERIMENTED WITH MAKE-UP AND HAIR DYE TO CREATE A UNIQUE, BISEXUAL LOOK. PEROXIDE MAY JUST BE ONE MORE DRUG IN THE LIVES OF THE ROCK FRATERNITY. NICO FROM THE VELVET UNDERGROUND, **KURT COBAIN, JOHNNY ROTTEN, BILLY IDOL, KYLIE MINOGUE, LOUISE, ANNIE LENNOX** AND **COURTNEY LOVE** HAVE ALL GOT HOOKED. WHEN **ROBBIE WILLIAMS** DECIDES HE NEEDS A PLATINUM FIX, THE DARK ROOTS SHOW THROUGH AS PART OF THE PACKAGE.

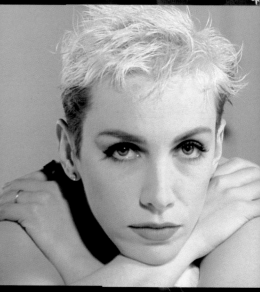

Years of serious bleaching have got many rock stars into trouble. Both Debbie Harry and Madonna have suffered from overprocessing their hair. This is the point at which only the experts can sort it out. Blondie went straight to Louis Licari for help, but lately, she's opted for what she calls the Cher method of hair care. She wears a wig.

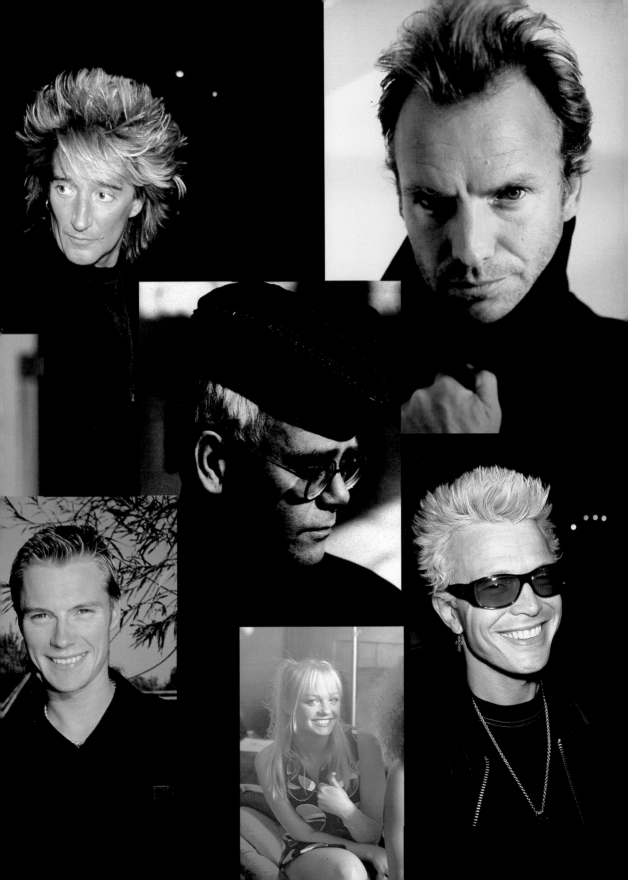

BLONDE LYRICS
(songs with 'Blonde' in the title)

'I'm a Blonde' from the album 'Earth Girls
 are Easy' by Julie Brown.
'Yard of Blonde Girls' from the albums
 'Sketches for my Sweetheart' and
 'The Drunk' by Jeff Buckley.
'Kleine Blonde Prinses' from the album
 'Welkom in Utopia' by Frank Boeijen.
'Blond' from the album 'Blond' by Rainhard
 Fendrich
'Suicide Blonde' from the albums 'All' and
 'X' by INXS.
'Blonde over Blue' from the album 'River of
 Dreams' by Billy Joel.
'Blonde in the Bleachers' from the album
 'For the Roses' by Joni Mitchell.
'Blondes with Lobotomy Eyes' from the album
 'A Crime for all Seasons' by My Life With
 The Thrill Kill Kult
'Sable On Blond' from the album 'The Wild
 Heart' by Stevie Nicks.
'Little Blonde Plaits' from the album 'Freaky
 Styley' by Red Hot Chili Peppers.
'Tired of Being Blonde' from the album 'Spoiled
 Girl' by Carly Simon
'White on Blonde' from the album 'White on
 Blonde' by Texas
'Blonde' from the album 'Seamonsters' by Wedding
 Present.
'Love Blonde' from the album 'Catch as Catch Can'
 by Kim Wilde.
'Little Dirty Blonde' from the album 'In the
 Heart of the Young' by Winger.
'Blondon Fair 6:022' from the album 'Collectors
 Item' by Twelfth Night.

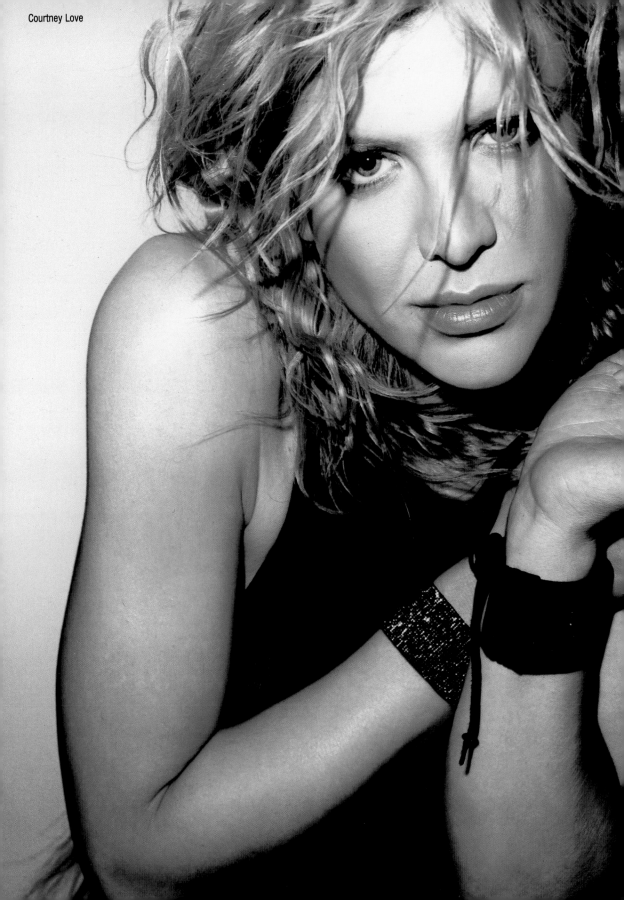

Courtney Love

Ice Blonde **Icons**

icon or **ikon** *ī'kon,* n. image, statue: painting, mosaic, etc., or sacred personage, itself regarded as sacred. [L. *īco¯n,* from Gr *eikōn* - image]

Superhuman, flawless, goddess-like, ice-cool, untouchable, enigmatic.

All these are attributes of the immortal blonde, an icon raised in status above mere mortals by the society of the times. The last half century has thrown up a new blonde icon for each decade but the angelic blondes in Venetian paintings, in myths and fairytales and in Hitchcock films are all examples of the women we wanted to dye for, to emulate and idolise. Icons often die tragically young or disappear from society which helps consolidate their perfection in the collective memory.

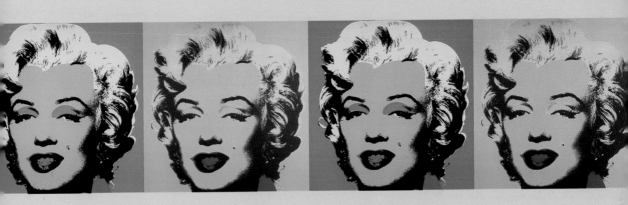

Not often carved in stone (although Brigitte Bardot was turned into a statue as Marianne, the symbol of France), they are immortalised in paintings (Andy Warhol's Marilyn series), photography or by impersonation.

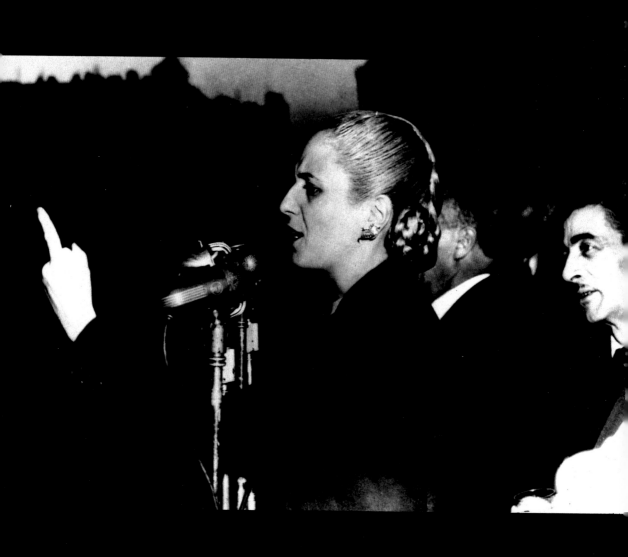

From reality to celluloid: Madonna personifies Eva Peron.

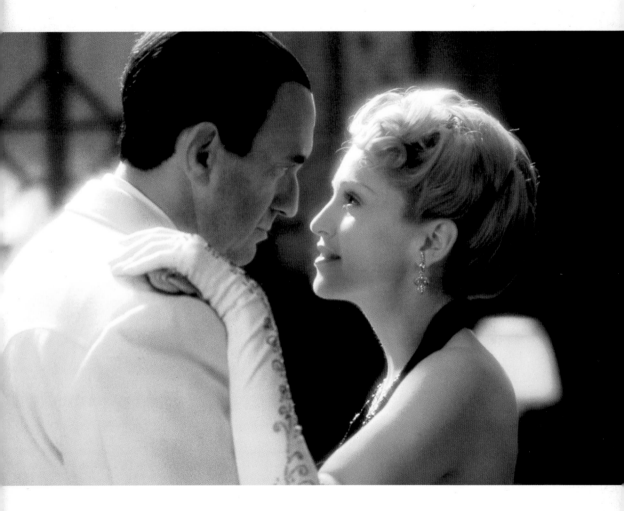

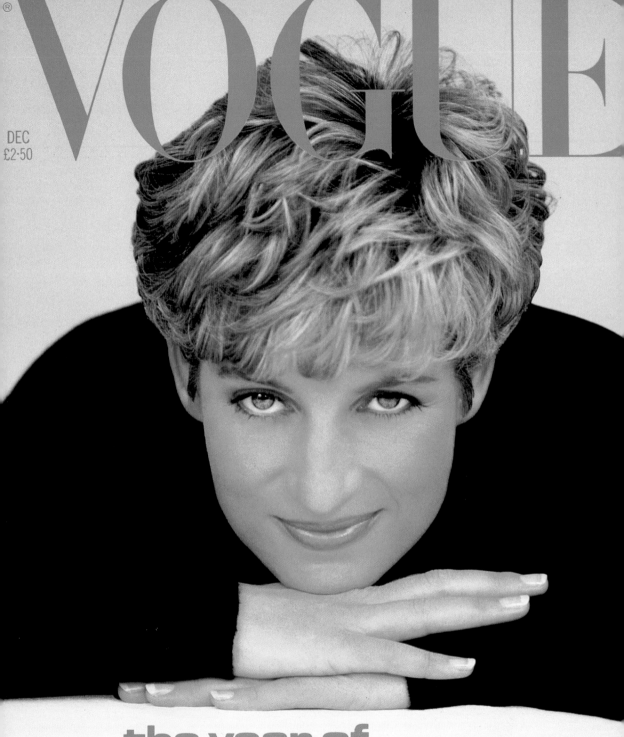

VOGUE

DEC
£2·50

the year of
dance
A CHRISTMAS CELEBRATION

Take Princess Diana, the most contemporary example of the divine blonde and Grace Kelly, her counterpart in the Fifties. Both these doomed blonde princesses fell in love with princes and both died in the same way, the public creating shrines in their memory. Jayne Mansfield, though not a princess, also ended her life decapitated in a car crash while Eva Peron, loved and treated as a princess, developed a terminal disease. Marilyn chose suicide. Jean Harlow was poisoned while Diana Dors just made it into her fifties before succumbing to cancer.

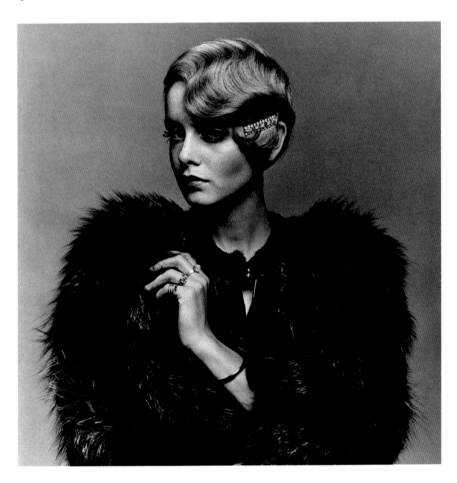

Some icons are thankfully still with us. Twiggy, an icon for the Sixties and Catherine Deneuve, whom Francis Wyndham described as 'a cool combination of the virginal and the vicious' and who rose from a bourgeois French background to become an actress with the enigmatic quality that makes her unique, are just two. Brigitte Bardot is still remembered as the breathtaking star of *And God Created Woman* while Ursula Andress can never be forgotten as the Bond girl in the white bikini rising like a modern day Venus from the waves.

AS THE BLONDE ICON FOR THE EIGHTIES,

MADONNA

WOULD UNDOUBTEDLY GET THE ACCOLADES FOR RE-WORKING THE MYTH OF MARILYN AND CREATING AN IN-YOUR-FACE

IMAGE FOR THE ERA

WHICH WAS PALPABLY PROVOCATIVE,

OVERTLY SEXUAL

AND IN NO WAY DIZZY

Contemporary idols are often created by, or at least beholden to their colourists and hairdressers. Jayne Mansfield wanted her hair to look like ice and forced her hairdressers to use 60% peroxide on it even though the result was that it looked broken and bitty. Madonna adored top session stylist Orlando Pita during her platinum phase, famously christening him

an angel sent down from heaven to do my hair'

while Orlando observed sagely that 'WHAT'S GREAT ABOUT GOING BLONDE

IS THAT WITH SO LITTLE

YOU CAN CHANGE YOURSELF SO MUCH.'

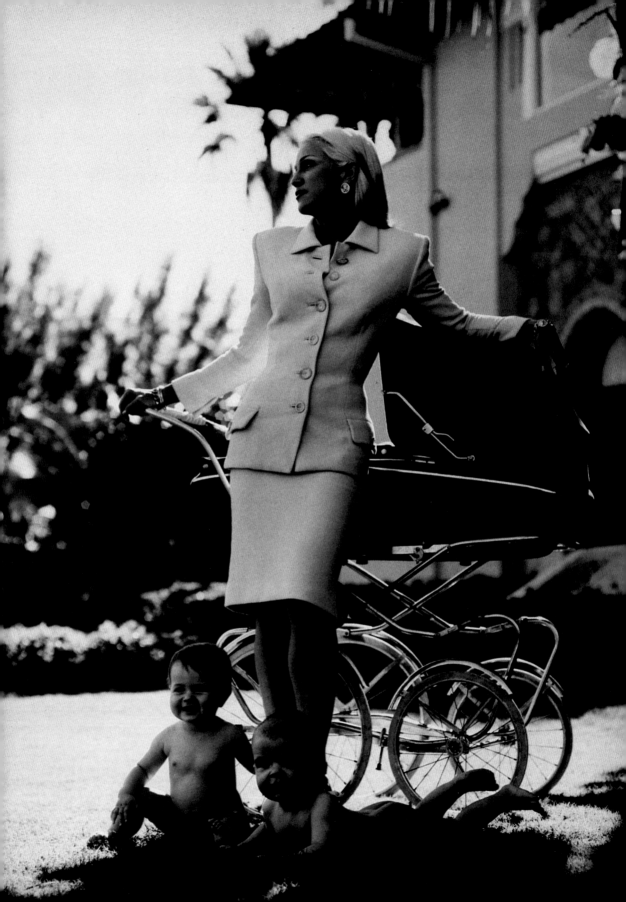

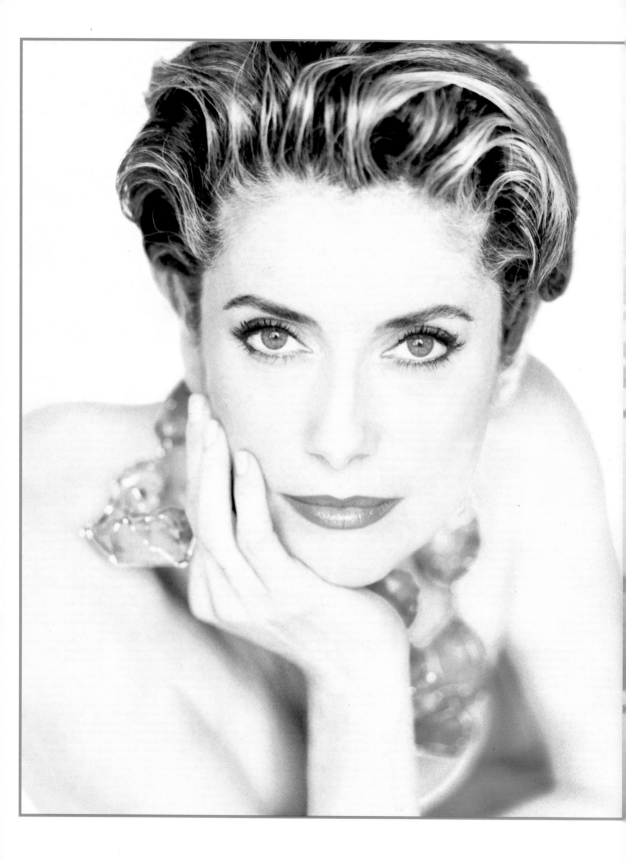

'For me, the ultimate blonde is Catherine Deneuve,'
argues Christophe Robin
who works his colour magic on the French international icon,
from a tiny atelier in central Paris.
'To be a blonde with class – that's special.'

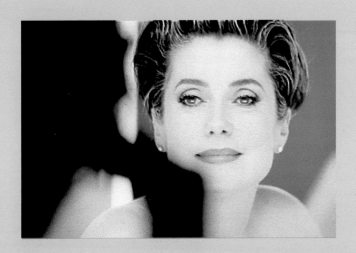

To peroxide an icon has to be considered at the very least a conversation stopper and New York society colourist Ron Levin, can claim to have been instrumental in the latter-day blonding of Marilyn Monroe. Fresh out of a hair college in Philadelphia at eighteen, he was working in a small, tacky middle-class salon called Louis and Simone, when the owner of the salon asked him if he'd like 'to go in the back and do Marilyn Monroe's hair'. There was a connection. The owner of the salon was the sister of Mr Kenneth, the hair salon in New York at the time. 'Of course I thought it was a joke,' says Levin, 'we had a colourful clientele, call girls and so on, and I said "sure" in a rather camp way and made my way to the back room which was, in fact, a makeshift laundry room. There was Marilyn Monroe sitting under the dryer with her feet up on four cartons of clean towels, her glass-heeled clear plastic mules kicked off, her Borgana fake fur discarded, in a black, very fifties polo-neck sweater and turquoise Toreador pants. As you can imagine I was terrified. 'Here was a woman who was more famous in America than Jesus Christ and I had to do her colour.'

Here was a girl – not that attractive actually – with broken blood vessels on her face and dry ashy hair which was already so overbleached. But she knew just what she wanted.'

'She told me very sweetly, "Just do my roots, bring them up very light and don't use any toner, then I can set my own hair and I'll go under the dryer." That is exactly what happened.'

'About three weeks later she called me up and asked me to come to her apartment and do it again. After that, I'd turn up at 400 East 57th Street, where she lived with Arthur Miller, and do her hair in private.'

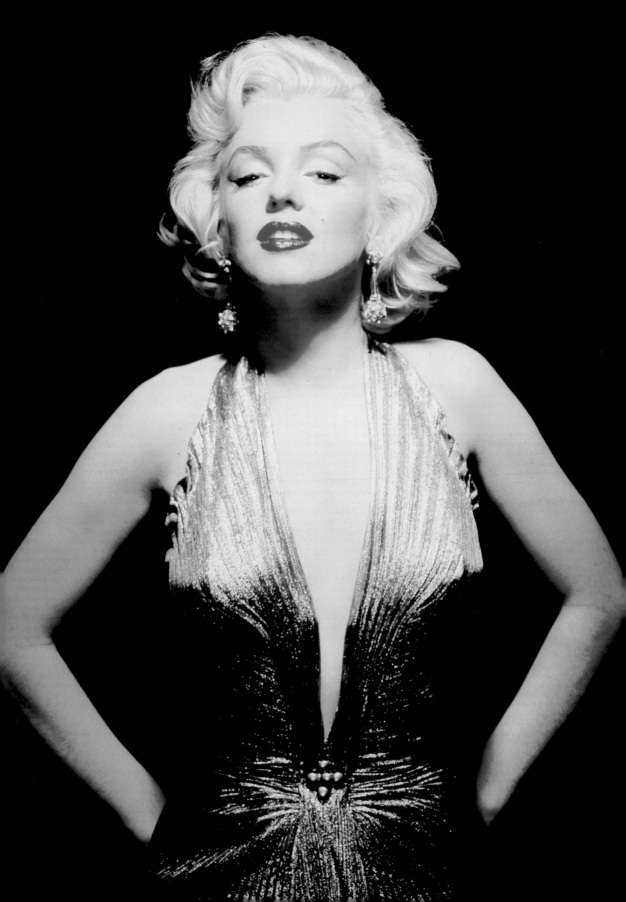

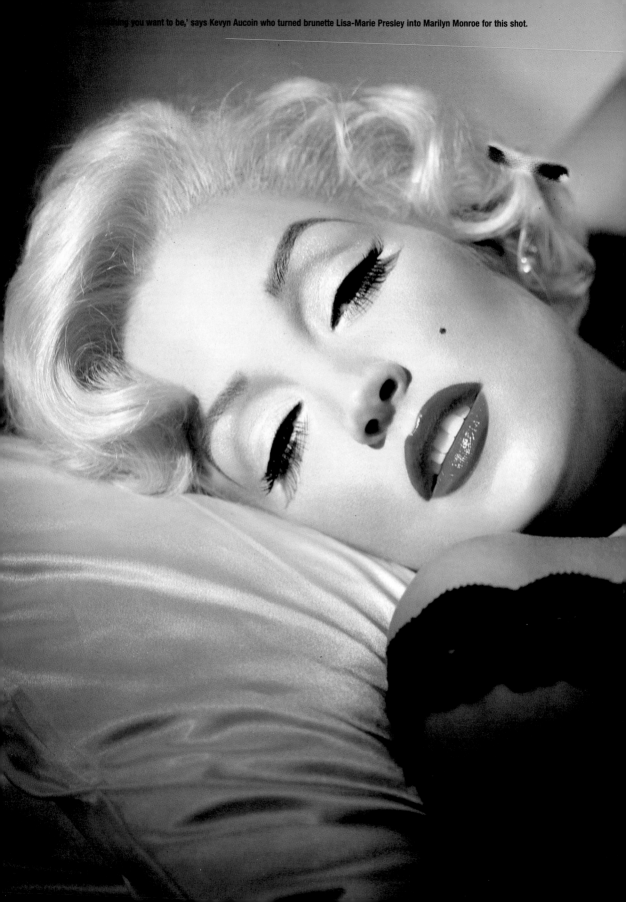

MARILYN MONROE'S
THICK BLONDE FLICK-UPS,
GRACE KELLY'S
GLACIAL SMILES
AND PERFECT CHIGNONS
AND DIANA'S
EVER MORE GOLDEN
HIGHLIGHTS
ARE ALL ICONOGRAPHIC
PROOF THAT BLONDES
LAST FOREVER.
BY TREATING THEM
AS SACRED,
THEIR MYTHS CAN NEVER BE
TARNISHED
BY OLD AGE
OR NEW REVELATIONS.
AFTER ALL
HOW WOULD WE FEEL
TO DISCOVER THAT
OUR HEROES HAVE
FEET OF CLAY?
THAT ALL OUR
HEROINES
ARE DARK
AT THE ROOTS?

The Gay Icon

is an important modern phenomenon because she's outrageous and also because she's warm and funny. She gets to say or sing all the things that gay men wish they had said or could say themselves if they dared to be so provocative. She looks the way they'd like to look too if they could get their hands on the dressing-up box and the peroxide wigs.

Marlene Dietrich
Bette Midler
Diana Dors
Barbara Windsor
Doris Day
Cybil Shepherd
Marilyn Monroe
Mae West
Dolly Parton

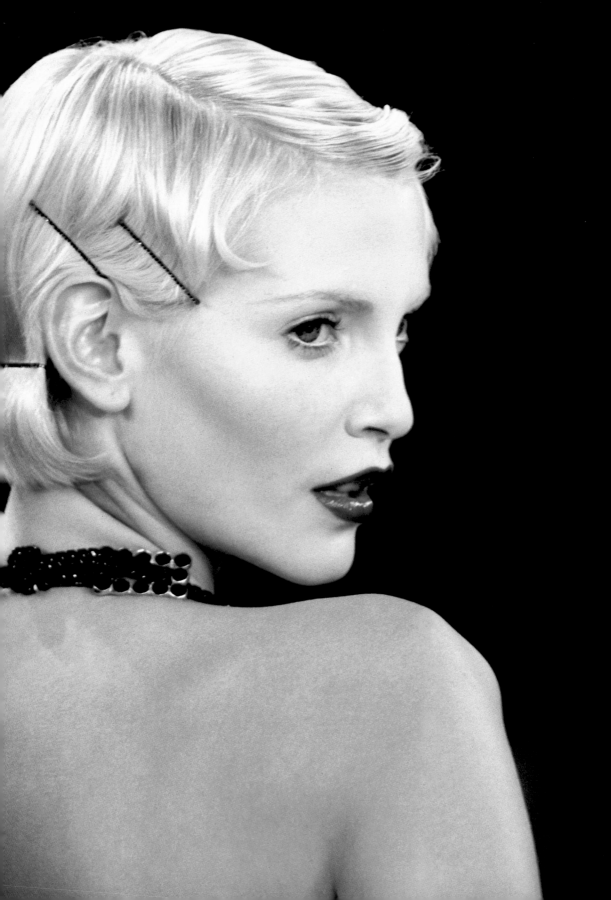

ALL'S FAIR
on the
catwalk

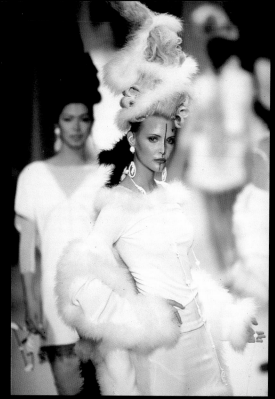

For models
the moment they go
blonde
their careers
take off
GIANNI VERSACE

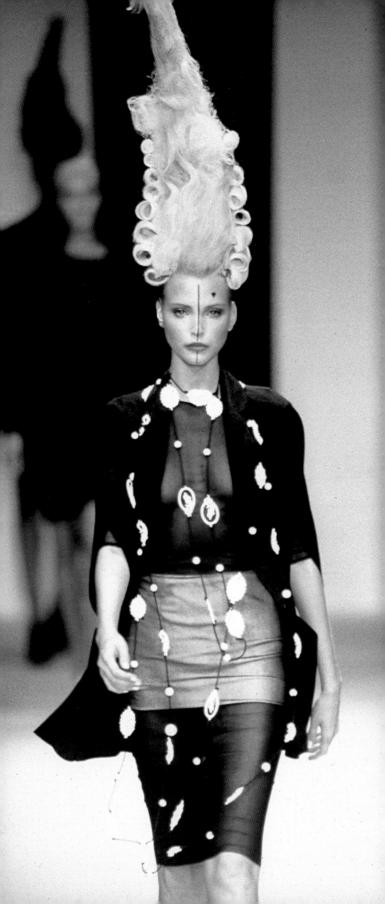

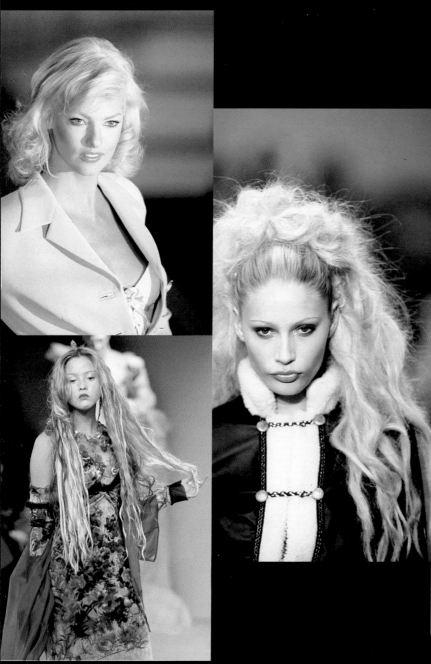

BLONDES

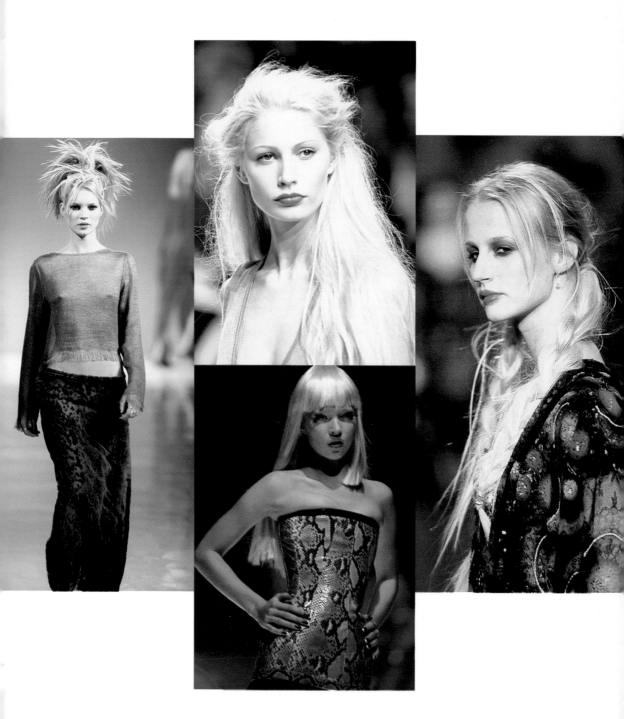

'EN MASSE'

It was Steven Meisel's idea. In 1991 Benjamin Forest and a group of friends were sitting around with Linda Evangelista when he turned to her and said

'I wonder what you'd look like, as a blonde?'

So they did it, there and then with whatever alchemy they had to hand, turning Evangelista into a Marilyn for the nineties and launching a whole new blonde trend for the decade. Linda got on a plane that night and arrived in London to do the George Michael video Freedom. Her hair was such a success that she featured more than anyone else on the video. She got headlines, she got *Vogue* covers and she led a catwalk revolution where even the most resolute brunettes (and she was one herself) like Kate and Nadja turned bottle blonde for a change of image.

'What I did to her is one of the most damaging things you can do to hair.' said Forest later. 'It was just a mood-of-the-moment thing.' Blonde soon became part of the zeitgeist. It was not just a catwalk trend where it soon became easier to count the non-blondes appearing on the runways. There was a trickle-down effect at the hairdressers. According to L'Oréal's statistics, between 1992 and 1997 in-salon colouring increased by a huge 71%, with blonde as the number one colour choice. Today that huge percentage applies to home hair colouring too.

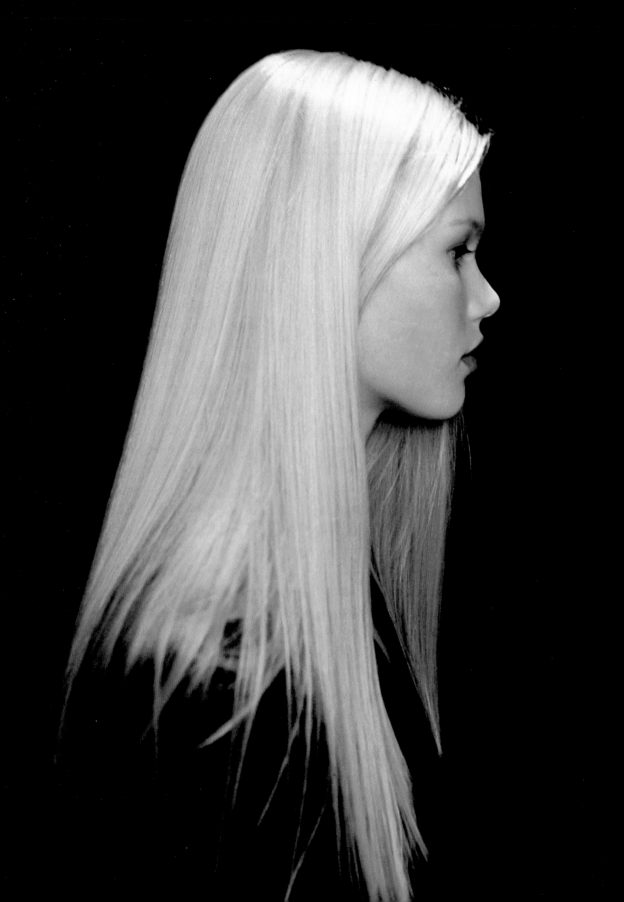

Blonde became a uniform, an accessory every bit as vital as the Prada handbag or the pair of Gucci shoes.

Part of this platinum parade was due to the fact that clothes were sombre and minimal. Blonde streaks, white flashes and tops on dark roots, and blatantly fake blonde extensions served as light relief to the pared-down wardrobe the designers served us up at the beginning of the decade. If the designers were being serious about the clothes, then the hairdressers got creative and up-beat with the hair. It was fun with the tresses not the dresses. Never before was blonde hair so flagrantly and conspicuously fake and never before so universal. Twiggy, Jerry Hall, Jill Kennington and Patti Boyd had all been famously and successfully blonde. But this was blondes 'en masse' which resulted in a phenomenon.

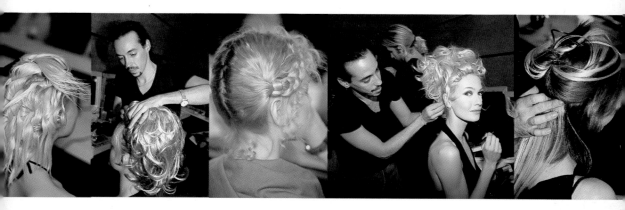

One by one, the supergirls took to the bottle.

Kate did it with Sun-In, Kristen did it courtesy of Christophe Robin in Paris, Claudia Schiffer personified the look for Chanel; Karen Mulder, Niki Taylor, Kirsty Hume, Carla Bruni and Amber Valetta simultaneously went a lighter shade of pale.

CATWALK COLOUR
MAY HAVE CALMED DOWN
BUT ITS IMPACT HAS HAD
WIDE REPERCUSSIONS
IN THE WORLD OF FILM AND THEATRE

Encouraging this model-blonde revolution all the way was the ultimate peroxide evangelist, Donatella Versace, nicknamed *la biondina* (the little blonde) by her brother Gianni when they were children in Southern Italy. At the 1995 Versace Couture show she launched her own scent, Blonde, with the message that it was 'a scent for the Blonde inside each of us'. As if to endorse her belief in blonde as a triumph of femininity, the front row of the show boasted Madonna, the number one blonde of the moment, strawberry blonde Jamie Lee Curtis and yellow-blonde Meg Ryan to complement her own unashamedly platinum signature mane.

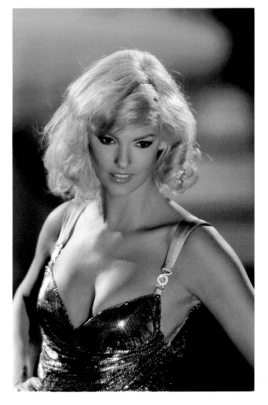

Inevitably, as fashion trends go, the vogue for wild blonding peaked and gave way to more idiosyncratic colouring and a new clutch of runway stars such as Carmen, Aurelie, Audrey and Maggie Rizer. But the bolder, blonder strokes have continued to have impact in hair salons where, according to Jo Hansford, described by *Vogue* as 'the best tinter on the planet', 95% of London's blondes are either unnaturally so or have had their hair treated to retain the colour. Catwalk colour may have calmed down but its impact has had wide repercussions in the world of film and theatre. Kristen Scott Thomas went surprisingly blonde for *The English Patient*. Gwyneth Paltrow cropped her hair and took it two to three shades paler, Meg Ryan's buttery shag got creamier with every film she did, all illustrating a new direction in fashion that could arguably be traced back to that quiet evening with Steven Meisel and friends.

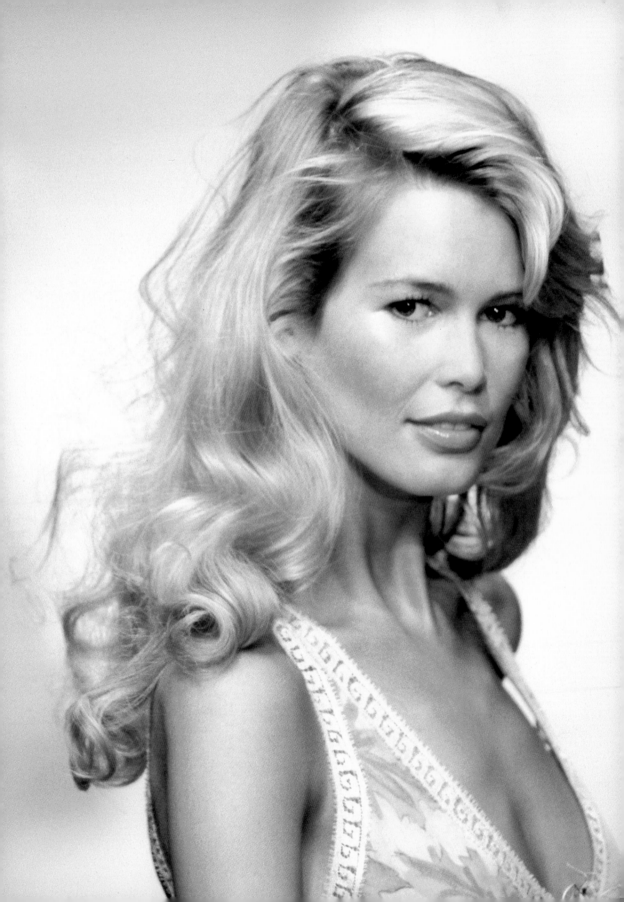

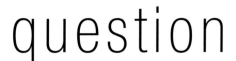

question

'A smart blonde, a dumb blonde and a unicorn are sitting round a table on which there is a £10 note. **Who gets the money?'**

answer

'The dumb blonde. **The other two don't exist.'**

smart blondes

This is a typical example of what you get if you feed the word 'blonde' into the Internet. Of course it's incorrect. Because the smart blonde not only exists, she's what the stereotypical blonde became. There are smart blondes everywhere, camouflaged as fluffy and ultra-feminine as they cunningly insinuate themselves right through the glass ceiling. Why should that be? Because appearances are deceptive. Because the packaging belies the contents. Because a whole army of ambitious women in a competitive world have chosen to hide their intensity and their burning ambition beneath a fluffy exterior in a cool considered bid to get their way.

'Scratch any dizzy blonde', says writer Laura Lee, 'and you're likely to find she's got a double first and a double life.' Not that it's anything new. The smart blonde's role model has to have been Lorelei Lee, Anita Loos's ingenuous gold-digging heroine from the 1920s. Named after the mythical mermaid (blonde of course) who enticed sailors to their deaths with her long, flowing hair and siren's charms, Lorelei hops delightfully from one benefactor to the next, acquiring diamonds, good times and even a husband along the way. 'Kissing your hand may make you feel very good,' she says, 'but a diamond and sapphire bracelet lasts for ever.'

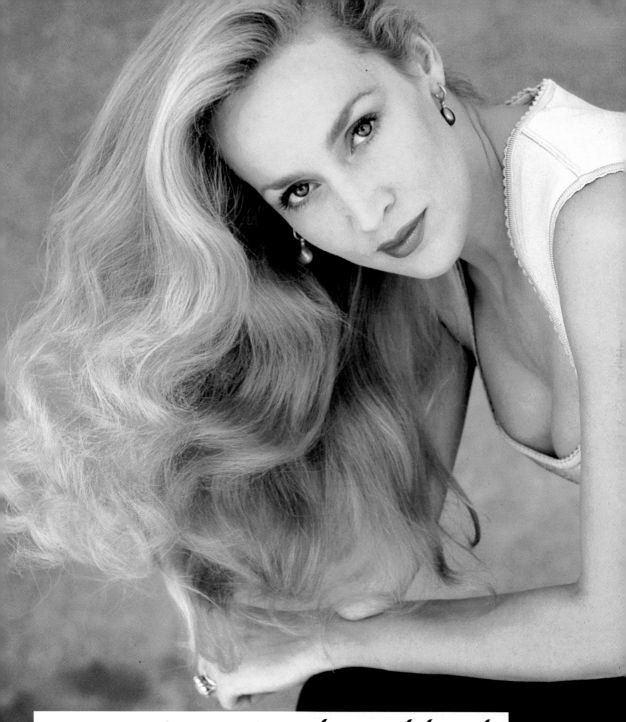

'Underneath this *dizzy blonde*, there is one very *smart brunette.*

Jerry Hall for L'Oréal

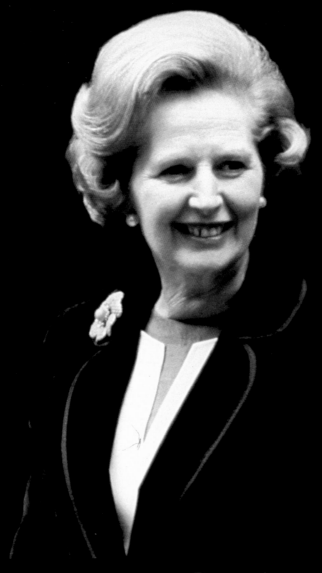

MARGARET THATCHER GOT BLONDER AS SHE BECAME MORE POWERFUL

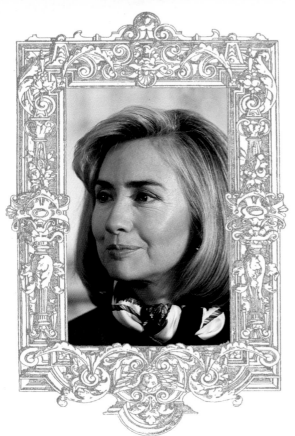

Today's 'dizzy blonde' has metamorphosed into a more sophisticated animal. She might aim for the Senate in lieu of a diamond bracelet (Hillary Clinton), a kingdom (Eva Peron), a rich husband or two and an ambassadorship (Pamela Harriman) or a seat in the House of Lords (Baroness Jay). Like Margaret Thatcher, who got blonder as she became more powerful, the road to prime ministership was paved with men who initially saw her as no threat and ultimately were putty in her hands. Blonde women seem to disarm men although many men may not admit it. These days they're probably not so much

after the diamond bracelet (they can buy that for themselves) as much as a seat on the board, a job with a future and an impressive bank balance.

The smart blonde who knows what she's doing keeps her Machiavellian cunning well hidden beneath her peroxide fringe.

TAKE ESTEE LAUDER,
WHO BUILT UP HER COSMETICS EMPIRE IN THE FIFTIES
WHEN ASKED IF SHE WOULD CONSIDER
JOINING FORCES WITH CHARLES REVSON OF REVLON
AND EXPAND INTO NAIL VARNISH.
HER BRUSQUE REPLY TO THE QUESTION WAS:
'I DON'T WANT TO GET INVOLVED WITH THAT MAN.
UP TO NOW HE THINKS I'M A DIZZY BLONDE,
IF I GO INTO NAIL VARNISH
HE'LL KNOW I MEAN BUSINESS.'

Like actress Joanna Lumley, who kept her high IQ quiet while she enjoyed success as a Bond Girl, and then surprised everyone by publicly scoring higher than A.J. Ayer in a celebrity Common Entrance exam contest, Lauder played the dumb blonde when it suited her and scored business points when the time was right. Nowadays, watching Lumley play the ultimate flake in *Absolutely Fabulous*, there is gravitas to her image because the world knows...

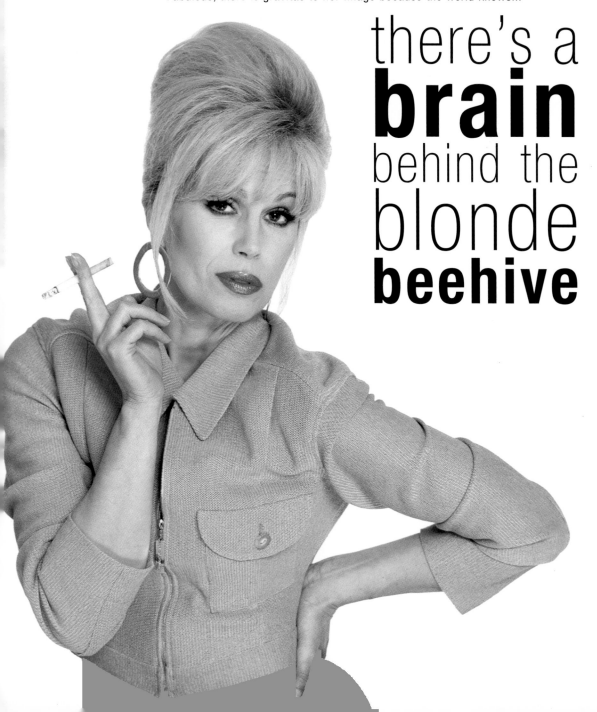

there's a
brain
behind the
blonde
beehive

Another bottle blonde with **brainpower** is Donatella Versace,

who scores points at every turn of her smart career.

First she was muse to her brother Gianni, then she became the personification of the Versace fragrance, confidently called Blonde in her honour. Now she is head of the multi-million dollar fashion empire, a role she took on when Versace was murdered. Other fashion blondes with global clout include Jil Sander and Adrienne Vittadini while models like Cindy Crawford, Cheryl Tiegs, and Claudia Schiffer have capitalized on their curves and their coiffure. Smart blondes may bleach their hair for a celluloid career (Meg Ryan, Michelle Pfeiffer and Sharon Stone) but the disarming appearance merely masks an enlightened career plan and iron resolve. Stars like Jane Fonda and Jessica Lange who started out as the entertainment factor in B-movies were only taking their first steps up the ladder. Goldie Hawn capitalized on her giggly blonde role in *Rowan and Martin's Laugh-in* in the Sixties and then built a film career round it. Her little-girl voice and child-like appeal have guaranteed success over a 30-year time span. Still giggling, still here. Along with the blonde curls, the all-woman curves and the appealing blue eyes, these smart blondes always had a steely focus on self-advancement. Now they're respected Hollywood success stories with adoring fans and grateful bank managers.

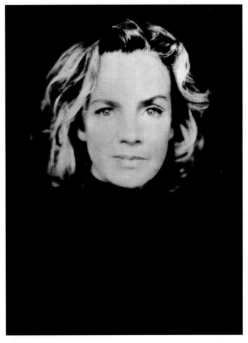

Smart blonde Jil Sander

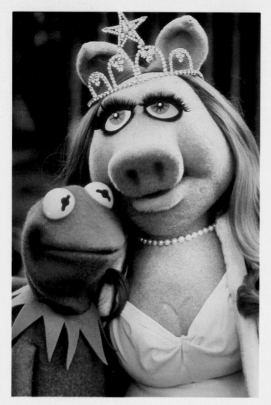

The blonde as Barbie-doll, space-cadet or prehistoric pin-up is losing ground to the smart blonde in contemporary films which now offer not-so-dumb blonde role models. Apart from Madonna as Evita, think of Michelle Pfeiffer taking on the school thugs in *Dangerous Minds* or Meg Ryan fighting her big business opponent in *You've Got Mail*, and almost any film starring Meryl Streep as a blonde.

Even make-believe and caricature blondes like Miss Piggy, Modesty Blaise and Tinkerbell who have all ended up as celluloid stars, are as cute as they come (and remember: the word cute actually comes from acute meaning sharp).

A modern template for the smart blonde in films was personified by Melanie Griffiths in *Working Girl*, who secures the deal, the dishy man and the devotion of the board of directors. Feminists must cringe when they see the way the smart blonde manoevres herself forwards. No guerrilla tactics, no heavy-booted sisterhood, no unshaven armpits, no anti-male manifesto. Today's Jean Harlow, personified by Meg Ryan, who irritatingly plays the sort of cutesy blonde in search of love that feminists would have hoped to have eradicated by the year 2000, is still a role model for girls who want to better themselves.

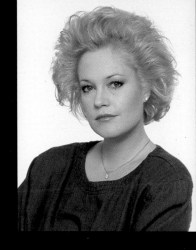

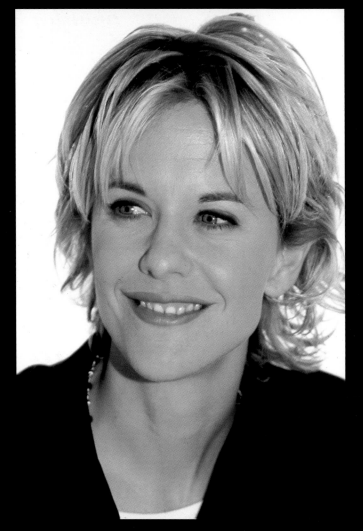

In no way politically correct, the smart blonde employs her own brand of strategy to achieve high stakes. The iron fist in the velvet glove, the baby voice and the fluttering eyelashes which help her delicately, sinuously and disarmingly all the way to the top.

The
BLONDE
BIBLE

GOLD DIGGERS

It would take the average woman nine months and a partner with an appropriate genetic background to create a blonde. A talented hairdresser can do it in less than 45 minutes. The natural blonde may be a dying species, but salons globally are already busy re-inventing her in shades of vanilla, strawberry, ash, gold, butter and ivory. And there's no evidence of a slow-down in the demand.

The blonde may well be the subject of a million dumb jokes, the target of the loud-mouthed hod-carrier on the building site and the envy of her dark-haired friends. Style pundits may decree that blonde is 'cheap'. The fashion world may decree that blonde is 'over'. Redheads and brunettes may stalk the runways, but the anti-blonde trend is only ever momentary. Look at the preponderance of blondes in the media, film and on the catwalk. There's clearly no substance to the rumours that her appeal is waning. In Clairol's latest survey 59% of women would rather be blonde than any other colour and 56% of men chose blonde as their favourite hair colour for women. On top of that there's no doubt that going blonde tends to be addictive. It's also expensive with a budget that hovers around £170 ($300) every three weeks just for upkeep. Those who try hard to kick the habit keep on going back. Those who start off with a hint of blonde, a few strands in the front, a subtle head of low lights, can never resist more and more.

THE RIGHT BLONDE FOR NOW

Blinded by science and hair technicians, the important thing to be at any time in history or fashion is – The Right Blonde for Now. There are no rules about this. Back in the mists of time, the RBFN was undeniably natural. When the Romans yanked off the locks of a warrior Scandinavian and wore her tresses as a trophy, it would hardly have had the same impact if they were bleached. When Clairol launched their first home hair colour in 1931, girls presumably wanted to copy the Jean Harlow look. Contemporary blondes have more recently coveted teeny weeny discreet highlights. Remember those advertising slogans which posed the questions 'Has She or Hasn't She?' and 'Is She or Isn't She?'

Nowadays even that subtlety is passé and, thanks to rockstars like Debbie Harry and punks and anarchists everywhere, the 'right blonde to be' was a brazen fake, with her roots determinedly showing – a streaky, chunky-striped blonde, who could never be thought to have Scandinavian genes. As colourists become the gurus of beauty, the shades and how they are applied tell the story. Now that it is so blatantly easy to be

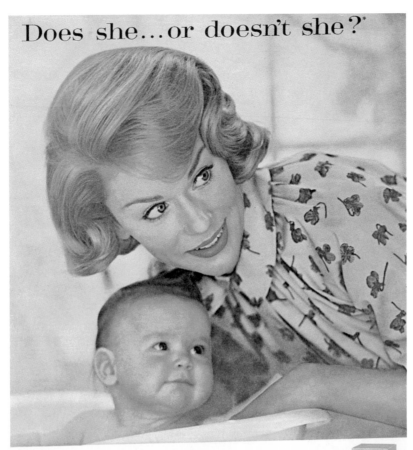

Does she…or doesn't she?*

Hair color so natural only her hairdresser knows for sure!

That wonderful feeling of security, so precious at any age, thrives on approval. *This* is as true for mothers as it is for babies—and she knows it! Her warmth, her fresh good looks, the radiant color of her hair reflect it! And when you think how quick and easy it is to keep hair beautiful with Miss Clairol, you wonder why *any* woman *ever* should let gray or fading color age her looks or undermine her confidence.

Hairdressers everywhere prefer Miss Clairol to all other haircolorings and recommend it as the haircoloring that truly lives up to its promise. Its automatic color timing is most dependable. And Miss Clairol *really* covers gray. But best of all, it keeps hair silky, lovely, completely natural-looking! So try Miss Clairol yourself. Today. Comes in Creme Formula or Regular.

CREME FORMULA

MISS CLAIROL

MISS CLAIROL® HAIR COLOR BATH†
THE NATURAL-LOOKING HAIRCOLORING ● MORE WOMEN USE MISS CLAIROL THAN ALL OTHER HAIRCOLORING COMBINED!

blonde for a day, an hour, or a week, the mystique of the blonde has changed irreversibly. Going blonde was never the act of an introvert but it has recently become the antithesis of mystery and rarity. The TV blonde as weather girl or presenter has none of the femme fatale allure of Novak and Kelly, nor the sensuality of Catherine Denueve in *Les Sauvages* or even the ingenuousness of Mia Farrow in *Rosemary's Baby*. A new generation of bleached *Baywatch* bimbos have changed the perception of the blonde as austere, cool and unattainable into an 'in your face' personality, as tough and opportunist as 'sandy-haired' Becky Sharp in *Vanity Fair* as well as dumb and dizzy. Dim and blatantly fake blondes (as the myriad of jokes on the Internet testify) have dumbed-down the species. Where do we go to from here?

ALL YOU NEED TO KNOW ABOUT BEING BLONDE

DYE FOR IT

You can go blonde for the weekend, for a special occasion or just because you feel like it. It may change your image but the minute you pick up that bleach (whether you do it yourself at home or go to the salon) it's permanent. And there's no stigma attached to being unnatural. In fact it's more difficult to spot a genuine blonde among the many brilliantly engineered fakes. Today's sophisticated processes mean that most of the time, damage from stripping and processing the hair can be avoided.

Jean Harlow's famous platinum hair broke off regularly because she anointed it with a mixture of household bleach, hydrogen peroxide, soap flakes and ammonia. She ended up like many film stars whose hair took a constant battering in the cause of their art; wearing a wig. We're not as mean to hair today. The professional formulas are gentler because tints have neutralising agents and have lower ammonia content. The whole process is more controlled and that's both in the salon and at home. Hair technology or hair-colour-speak is somewhat overwhelming. Especially as no two colourists agree. Some don't like hair painting, some don't use 'traditional developers', some use different volumes (strengths) of peroxide, some don't like colour shampoos, some have produced their own colour shampoos. Most agree that there's no such thing as a vegetable colour to make you blonde without peroxide. You have to use bleach to go blonde. Even the vegetable colours that claim to be 99% natural have to have bleach in them for your brown hair to lighten. So before you enter the salon or take that box off the shelf, the would-be blonde needs to have clear ideas of her own. Today changing the colour of your hair is as normal as changing your make-up or your clothes. But there are a few obvious pitfalls.

Chlorine and cigarettes are just two of them. Nicotine staining has much the same effect on all colours of hair. It's just that it shows up more on blondes. Film stars have historically had problems with overload.

Debbie Harry, Madonna and Paula Yates are just a few contemporary dye-hards who found, like the early Hollywood blondes, that their hair was breaking off. Trichologist Philip Kingsley remembers one hysterical American star who arrived at his Mayfair salon with a ball of tangles (a rat's nest in salon-speak) behind her ear. The only solutions were drastic cutting or infinite patience. 'It took 3 of us 2 whole days to comb it out, each using a toothcomb. She had fine hair, like most blondes, and she'd had too much colour and not enough condition. She was beside herself.' Problems can be accumulative, apart from the obvious one: too much colour; swimming, cigarettes, using hot dryers, straightening and curling irons, exposure to wind, cold and sun are all potential dangers. If the colourist is inexperienced and changes the temperature or humidity as the colour is developing, this can also have drastic results. Help is on the drugstore shelves in the form of chelating shampoos and special stronger conditioners but the hairdresser or trichologist will have more effective professional products to help rectify damage.

DO IT YOURSELF BLONDE
(HERE'S THE SCIENCE BIT...)

More people are dyeing their hair at home than ever before. And that's a global picture. This has been made easier with an ever-increasing range of options in a box and simpler clearer methods for choosing, mixing and application. However tampering with the bleach is a serious step so it pays to have a short physics lesson before you start. For instance, the darker your natural hair colour, the more difficult it is to lift the colour out of your hair. When you apply bleach to black hair, the first colour to come out as the bleach lifts or strips away the natural colour molecules is the black (this happens when you're in the sun too). For brunettes, it's the red, the orange and finally the yellow. The lighter you're trying to go the higher the volume of peroxide you need – and the longer you'll need to leave it on.

If you buy a product that is described as a blonde 'permanent,' don't expect to be a light ash blonde if you start with dark brown or brown hair. These products can only lift a few shades so you will be orange if applied to the wrong base colour. Check the package for starting tone before using. Technically a permanent, which lasts two to three months, works as follows: the action of the ammonia opens the cuticles to allow the colour molecules to penetrate. The hydrogen peroxide removes the natural colour molecules in the hair. The new colour molecules then form in the hair shaft. After tinting, hair is shampooed and this process closes the cuticle and locks in the new colour. Colouring hair at home needs concentration. Jo Hansford advises 'always read the instructions twice. Most of the mistakes I see are from people not following directions properly. Personally I

would stick to semi-permanents, as it's difficult to tint hair at home.' However a semi-permanent which contains neither ammonia nor hydrogen peroxide will not help a brunette go blonde. Vegetable dyes are good for those who are allergic to chemicals but remember, they are also unable to turn dark brown hair blonde.

ARE THERE ANY RULES?

One of the rules is never to go more than three shades lighter than your own hair. However, all the hip hair colourists say rules are there to be broken. The general rule is that the darker the hair, the warmer the blonde tones should be. The first decision is to be clear about the image you're after. There are so many techniques of hair colouring now that it's important to know whether you want tinting, partial lightening, classic foil highlighting, tips, slices, shading, freehand, polishing, icing, marbling, sponging or stippling.

Here are some of the options:

The Sophisticated Blonde tends to go for highlights which are put through all over to get a subtle build up of colour. Also you don't need to do it more than once every 2 to 3 months. It can be flexible.

The Power Blonde chooses an all-over colour which is strong, solid and definite. This would have to be tinted all over so that none of the original colour is left. This is the highest maintenance because the parting will need re-touching every 2-4 weeks without fail. Without that sort of help you become:

The Chip Shop or Trailer Park Blonde Gary Burke at John Frieda named the Chip Shop Blonde with the dark parting showing. Of course pop stars from Debbie Harry onwards have championed this look as stylish. Don't knock it – some people actually choose this option.

The Swedish Blonde You would think, of course, that a Swedish blonde was a natural blonde. But even natural Scandinavian blondes enhance their colour and genetically they have the skin and hair to go to the very whitish shades. Ulrika Johnsson's passport states that she is a 'middle blonde', presupposing that Scandinavians officially recognise the varying categories of blonde.

The Big Blonde might choose a combination of a tinted base and coloured lights as well, which would involve using a lot of colour.

The Beach Babe could choose stippling, icing or painting on – anything that results in a hazy sun-kissed look. There are several techniques here. The French tend to use a system called balayage which involves painting the bleach or tint onto cling film or cotton pads. The disadvantage with this is that the ammonia fumes from the bleach can distort the base colour (the client's original hair colour) making it orange because there's no foil to protect the hair underneath and in-between.

You need to be sure of which shade of blonde suits your skin and hair, which process suits your lifestyle and how much maintenance you will need to keep your new blonde hair looking the way it should. These are the questions you should consider.

Which shade? The choice of shades now includes honey, vanilla, strawberry, platinum, pearl, ash, light beige, several shades of gold or more romantically Aveda's Enlightenment shades christened Dawn, Sunrise, Daylight, Dusk and Eclipse. 'One big mistake', says Daniel Galvin, 'is that clients ask to be lighter when they actually mean brighter. Lighter and whiter can end up flat in tone. Bringing in a picture can help but it could be a picture of a dog or a piece of furniture. It's all about texture.'

Which hair type are you? Bear in mind the texture of hair when contemplating colour changes. Thick hair suits highlights or lowlights, thin hair is usually better with an overall colour which will need to be retouched every four weeks on average.

Which style? Think about the style as well. Very short or straight hair won't suit highlights unless you want a dappled, tabby cat, leopard-like effect which would be almost painted on.

It's good to talk: Get a free consultation from a colour specialist to ask advice before you take the plunge. Take along pictures or swatches of colour, so that what you have in mind and what the colourist has in mind are the same from the start. What's brown to you may well be dark blonde to her.

Tell the truth: Own up to everything you may have done to your hair before a new colour process takes place. Find out how much maintenance you are going to need with your new colour.

Try on: Try wigs and hairpieces if you can to get a clear idea of how the colour will look against your skin.

Take care: Avoid the overuse of heated rollers once you've coloured your hair. Think of your hair as a delicate fabric – it's easily damaged. Respect it like you would a piece of silk.

Vital changes: Don't forget to re-think your make-up with your new hair colour. What you used before will not work in the same way now. When you come back from holiday with more colour in your skin you should modify your make-up again to suit both your skin and sun-kissed hair. Always use a conditioner if you have tinted hair. Don't use your dryer too hot. Too much heat can be as damaging as the chemical process itself.

YOUR QUESTIONS ANSWERED

Q. What happens if I squeeze lemon juice on my hair when I'm at the beach or use one of those spray-on lighteners? A. Hair experts agree that the worst thing some parents do for their children is to put lemon juice on their hair. Lemon is an acid. It dries the hair and gives harsh and uncontrollable results.

Ultimately the hair could break. The same with the sprays especially if your natural colour is dark. Then, the hair will turn eggy yellow. It's safer if you're fair but constant use will destroy the hair.

Q. What if my skin colour is pink in tone and my hair is dark brunette? A. Choose neutral tones. ash blonde, ash brown. Yellow blonde would be a disaster for this skin tone.

Q. What if my skin is creamy white, ivory or white-ish in tone and my hair is fair? A. You can wear any colour, but if your hair is dark, too bright a blonde might bring out too much red in the skin.

Q. What if my skin tone is pink and my hair is fair to blonde? A. Stick to ash blonde from very light to mousy blonde.

Q. What if my skin is creamy white but my hair and eyes are dark? A. Use gold, bronze or reddish blonde lights.

Q. What if my skin is pale, pinkish and freckly and my hair is red/auburn? A. Not a good ideal colour for any blonde.

Q. What if my skin tone is yellow/sallow? A. Stick to cool (non-gold) hair colours with blue notes.

Q. What if my skin is olive? A. Stay dark but put in a few lowlights up to two shades lighter if you like.

Q. What if I went blonde for the weekend? A. If your hair is an inch long all over you can do anything you like.

Q. What if before I went on holiday I bleached my hair blonde at home (or at the hairdressers). Then having bleached it some more in the sun, I decided to go darker, say a light brown?
A. Disaster. Buy a light brown permanent tint and put it on your blonde hair at that point and you'll go green (because all the natural red has been stripped out of your hair). Only an expert can get you back in stages, adding red first.

IF YOUR NATURAL HAIR COLOUR IS...

Black: don't go lighter than a warm mahogany.
Dark to light brown: have streaks/highlights of amber, deep chestnut to mid golden.
Dark to light blonde: choose warm shades of honey, copper, wheat, apricot, pale blonde.
Blonde to grey: choose anything from golden blonde to palest ivory.
Red: have pale or bleached highlights.
Christophe Robin starts his assessment of the rules with eye and skin colour. 'Dark eyes and skin should be a warm blonde. Certainly if you're 'of a certain age' the contrast between skin, eyes and hair should be subtle. Pale skin, beige in tone can go very blonde he says.

BLEACHED BEACH BABES
HOW TO LOOK AFTER YOUR HAIR IN THE SUN

The sun, the sea, the shower and the chlorinated swimming pool are all danger zones for coloured hair. Unless you're careful on holiday, the subtle tones of your blonde highlights or rinse will change. Regular pool devotees will find their hair going green thanks to mineral chlorine and chemical build up from the hair shaft. Chlorine is as much of a permanent danger as bleach itself. It really eats into the hair, even virgin hair, which is why even fair children who swim all summer without regular rinsing end up with green hair that's all but impossible to shift without resorting to the scissors. Dyed hair is even worse. Bleach plus chlorine is like bleach on bleach. The only solution is a swim cap. Chlorine, most of all can give you a green tinge to the hair. The sun will bleach your hair more than before and dry it out. This can be attractive on holiday but in the cold light back home, can result in tawdry and vulgar colour.

- Always be careful to condition your hair after colour. Choose a shampoo and conditioner specially formulated for colour-treated hair.
- Deep cleansing shampoos will lift tint faster.
- Look for shampoos with panthenol to strengthen and protect the hair shaft.
- Wear a hat when sunbathing.
- Tell your colourist when you're going on a sun holiday.
- When swimming wear a cap and/or a protective swimming cream.
- UV light may fade colour faster so wash hair daily with a shampoo containing UV protectors.
- Look for words like chelatin and panthenol on conditioning shampoos.

STATISTICS

- Blondes have more hair on their heads than brunettes. Approximately 140,000 compared with 108,000 for their dark-haired friends.

- 8.4 million women (37%) in Britain colour their hair. Half of that number colour their hair at home.

- 10% of the UK market in haircare sales comes from colourants. It is the fastest growing sector. (Source: Wella)

- Global sales of colourants almost doubled in the five years between 1993/1997.

- Sales of colourants in the USA exceeded $1 billion in 1997.

- In the USA colourants have been the fastest growing sector in the hair care market. Approximately 60% of French women dye their hair, 54% of them choosing to do it at home – an increase of 40%. In the UK the market is worth $214.million. In Germany 45% of women are estimated to colour their hair now. Japan ranks second in global demand for hair colour.

the goldilocks gang

(A WHO'S WHO OF COLOURISTS)

'Life as a brunette in New York is cold and lonely.'

Plum Sykes

High profile actors, film stars, models and socialites sometimes appear on the client lists of more than one top colourist. This can be because they find themselves working on a film in Los Angeles or worse still on location in the wild, and not able to get back to New York or Paris for their regular appointment. There are those, however, who just can't trust another pair of hands with the bleach. The idea of the colourist, as separate profession, is a relatively new phenomenon but with hair colour as the fastest growing sector of the hair care market, it's a profession that is proliferating. Ron Levin, who can claim to have coloured the hair of

not only Marilyn Monroe but Grace Kelly, Jayne Mansfield and Farrah Fawcett Majors, to name just a few, now only works four days a week in New York and never does house calls. The fair and the faithful come to him, one client notably arriving on Concorde from Paris and returning the same day. But Levin did his share of private calls back in the early seventies, as did Daniel Galvin whom Twiggy famously used to fly to the US to keep her roots re-touched. This was because in those days there were fewer really gifted colourists around and a star just about to go under the spotlight needed to be super confident of her capillary perfection. There are great tales of tantrums from the tinting room. When needs must, colour can be touched up anywhere.

Many of the top colourists are more than familiar with the interiors of private jets as the wealthy whisk them wherever, whenever their roots are showing, although most of them are too discreet to brag about their bleaching. Jo Hansford will be chauffeured to a society wedding or film set; Sharon Dorram has been flown down to Los Angeles to touch up Nicole Kidman's highlights, Christophe Robin, youngest contender to the colourist throne, leads the jet set life, while Christophe Schattemann in Los Angeles is more at home in Clinton's Air Force One than some White House staff.

In Paris Christophe Robin offers a tinting and highlighting service only in his tiny atelier and intends to remain a specialist, an artisan, leaving cutting and drying skills to others. Luckily for him, John Frieda has opened a salon, a comb's throw away. 'All good colourists have their own aesthetic signature,' says Sharon Dorram, originally an art school graduate, as was New York- and Los Angeles-based Louis Licari, who modestly calls himself 'The king of colour'. Both believe that hair colour is an important accessory and a minor art form. Like finding the right person to paint a portrait, today you need the right person to wield the peroxide.

New York

SHARON DORRAM at JOHN FRIEDA

John Frieda Salon, 30 East 76th Street, New York, tel: 212 879 1000.

Client List: Julia Roberts, Joan Lunden, Meg Ryan, Marie-Chantal of Greece, Anne Heche, Brad Pitt, Annie Liebovitz, Lisa Kudrow, Elle MacPherson, The Miller Sisters.

Soundbite: Known for emulating the hair colour of a child and her natural look which often involves layers of highlights: 'I aim for the look of the little girl who's been on holiday at the beach.'

Facts: Every day Sharon uses 1250 sheets of tin foil and 20 pairs of rubber gloves. 60% of her customers want blonde. On a peak day she manages up to 40 clients. Thinks that the right hair colour is like wearing the right make-up. Loves blonde on blondes looks on many American women because of its glamour and opulence.

LOUIS LICARI

797 Madison Avenue, New York, tel: 212 517 8084.

Client List: Sharon Stone, Lisa Marie Presley, Susan Sarandon, Mira Sorvino, Sophia Coppola, Kirsty Hume.

Soundbite: 'You can't always have the longest legs or the perkiest breasts, but being blonde is the part of the fantasy that you can achieve.'

Facts: Licari trained as a painter and has been a consultant to Clairol since 1984.

CONSTANCE HARNETT at FRÉDÉRIC FEKKAI

Chanel building, 13 East 57th Street, New York, tel: 212 583 3200.

Client List: Kim Basinger, Lorraine Bracco, Christie Brinkley, Faith Ford, George Hamilton, Ann Jones, Nan Kempner, Jessica Lange, Grace Mirabella, Leno Olin, Jane Pauley, Paulina Porizkova, Natasha Richardson, Jane Robelot, Stephanie Seymour, Martha Stewart, Adrienne Vittadini, Sigourney Weaver, Paula Zahn.

Soundbite: 'So many brunettes lose their sensuality when they go blonde. There is such a coolness about blonde hair.'

RON LEVIN AT PIERRE MICHEL

131 East 57th Street, New York, tel: 212 593 1460.

Client List: 'All the Hearsts, all the Rockefellers, all the Newscasters', Barbara Westin, Nancy Sinatra.

Soundbite: '90% of Americans have base colour first and then highlights on top. For delicate hair I use German bleach by Wella. This gives a bright pale gold. I prefer it for my important city women to the whiter ashier look you get with Clairol's (Basic White).'

CHRISTOPHER JOHN AT PETER COPPOLA

746 Madison Avenue, New York, tel: 212 988 9404.

Client List: Madonna, Courtney Love, Caroline Bessette Kennedy, Amber Valetta, Carolyn Murphy, Ashley Judd.

Soundbite: 'There's a little bit of blonde in everybody.'

'I know the minute I look at someone what to do with their colour. I think whatever you do it should always look as if it could happen in nature. And yes, my favourite look for Madonna is still strawberry blonde.'

California

ART LUNA

8930 Keith Avenue, West Hollywood, California, tel: 310 247 1383.

Client List: Kelly Lynch, Ellen DeGeneres, Melanie Griffiths, Rosanna Arquette, Candice Bergen, Rees Witherspoon, Anne Heche, Don Johnson, Lauren Hutton, Cheryl Tiegs.

Soundbite: 'Beach blondes, that's what people here usually ask for. That sun-kissed look. This is the town of blondes after all. The types separate – Hollywood blondes and California blondes, the latter representing that beach blonde, lighter on top and darker underneath.'

Facts: Luna is currently looking for a second salon on the beach so you can literally be there as your hair gets the look. Has his own brand Healthy Highlights Enhancing Shampoo and Hair Lightening Gel.

CHRISTOPHE SCHATTEMANN

Christophe Salon, 348 North Beverley Drive, Beverly Hills, 90210, tel: 310 274 0851.

Client List: Bill Clinton, Rosanna Arquette, Goldie Hawn, Nastasia Kjinski, Kelly Preston, Pamela Anderson, Sharon Stone.

London

JO HANSFORD

19 Mount Street, London, tel: 0171 495 7774.

Client List: Carla Bruni, Patti Clapton, Sharron Davies, Amanda Donohoe, Melanie Griffiths, Alex Kingston, Yasmin LeBon, Olivia Newton John, Camilla Parker Bowles, Kylie Bax, Kate Winslet, Rachel Hunter, Zoe Ball.

Soundbite: Maintains that 95% of London's blondes are either unnaturally so or have had their hair treated to retain the colour. Paradoxically Jo says 'I love making blondes dark.' American *Vogue* called Jo 'the best tinter on the planet'.

Fact: First turned David Hemmings blonde for *Blow Up*. Then turned Nigel Havers blonde for *Chariots of Fire*. Has her own brand Couture Care for colour-treated hair.

DANIEL GALVIN

42–44 George Street, London, tel: 0171 486 8601.

Client List: Stephanie Beecham, Richard Gere, Nicole Kidman, Tom Cruise, Cher, Faye Dunaway, Anna Friel, Mel Gibson, Stephanie Powers, Joely Richardson, Vanessa Redgrave, Lynn Redgrave, Twiggy, Catherine Zeta-Jones, Jane Seymour.

Soundbite: 'It's helpful to get a picture of the hair someone would like but it doesn't have to be a person. It could be a dog or a piece of furniture. It's all about the texture and colour.'

Fact: The first to blonde Princess Diana and Twiggy. Very pioneering work in the colour field in the Seventies. Now teaching colour in Japan where they can't get enough. Has been awarded every global hair colour award imaginable and has his own brand products. Started working with Vidal Sassoon and Leonard.

JOHN FRIEDA

4 Alford Street, New Cavendish Street and Claridges, London, tel: 0171 491 0840.

Client List: Sheryll Crow, Tom Cruise, Meg Ryan, Donna Karan, Nicole Kidman, Kate Winslett, Zoë Ball, Duchess of Gloucester, Liam Gallagher, all British beauty editors.

Soundbite: Sue Baldwin, Technical Director of the Colour Team says 'British women tend to be more individual with their colour. In other countries they seem to be formulaic.' (I'll have what my friend's having.)

Fact: Has a complete range of shampoo, conditioner, mousse and wax, named Sheer Blonde, especially for blondes.

DAVID ADAMS

Aveda Institute, 28–29 Marylebone High Street, London, tel: 0171 317 2100.

Client List: Alex Kingston, Amanda Redman, Bjork, Cher, Donald Sutherland, Kylie Minogue, Minnie Driver, Sadie Frost, Sting, Jude Law, Anna Friel, Jane Horrocks, Spice Girls.

Soundbite: 'Blondes can be either glamorous (Marilyn Monroe), sexy (Debbie Harry), romantic (Gwyneth Paltrow) or Dizzy (Meg Ryan, Goldie Hawn).'

Fact: Has worked on the following films: *Bull Dance*, *Dry White Season*, *Life is Sweet*, *Secrets and Lies*, *Shopping*, *Event Horizon*. In the theatre: *Bugsy Malone*, *Six Degrees of Separation*. For television: *EastEnders*, *ER*, *Heartbeat*, *Inspector Morse*, *Kavanagh QC*, *Martin Chuzzlewit*, *Moll Flanders*, *Poirot*, *Sense of Guilt*, *Soldier Soldier*.

Paris

CHRISTOPHE ROBIN PARIS

7 rue de Tabor, Paris, tel: 331 42 60 99 15.

Client List: Catherine Deneuve, Kristin Scott Thomas, Neve Campbell, Linda Evangelista, Claudia Schiffer, Christy Turlington, Emmanuelle Beart, Johnny Depp, k d lang, Nadja Auermann, Mila Jovovitch, Kate Moss, Vanessa Paradis, Fanny Ardant, Isabelle Adjani.

Soundbite: 'A great colour is going to bring out the very best in a client's eyes and skin.' 'I'm just trying to be a good professional.'

Fact: The first atelier in the world to specialise only in colour. He doesn't cut and he doesn't set. However, having started with the transformation of top models for advertising and catwalk, where he has on occasion changed a model's hair colour three times in a day, he knows all the possible problems and solutions.

Colour work on films: *The English Patient*, *The Horse Whisperer*, *Mission Impossible*, *La Neuvième Porte*, *Jean D'Arc*, *Place Vendome*, *Pola X*, *Voleur de Vie*.

Germany

PETER DAWSON at VIDAL SASSOON

Vidal Sassoon, Neuerwall 31, 20354 Hamburg, tel: 49 403 614 1111.

Client List: Jil Sander, Marius Muller-Westerhagen, Anja Silia, all the girls from the Bauer dynasty.

Soundbite: 'The Germans have a passion for blonde – the archetypal sunny blonde with blue eyes. Because their natural base colour is flat and ashy and they have pale skin, they need warmer tones put into it to give it life – I even put in honey and gold and even apricot.'

Fact: Does more blondes than any other colour.

A *Blonde* BATTLE PLAN

BY JOHN FRIEDA

We have always recognized the special allure and psychological impact of blonde hair. In our salons, we have often seen the 'mood lift', in addition to physical brightening, that results from a few well-placed blonde highlights

But we have also seen the downside of blonde… everyday in our salons, we've experienced problems with blonde hair that don't apply to darker hair shades. To address these problems, about two years ago we at John Frieda Professional Hair Care set out to develop 'Sheer Blonde', a line of shampoos, conditioners and styling products designed to meet the unique needs of blonde hair.

Our first order of business was to collect every bit of data — every last shred of information we could get our hands on regarding blonde hair. The statistics were startling. Although we had always suspected blonde was a popular hair hue, we hadn't realised just how popular.

While 30 per cent of the population is born blonde, salons report that up to 75 per cent of clients get colour-lifts or highlights on a regular basis. And as baby-boomers age, that number is rising, with blonde being the number one colour choice to camouflage grey. Add to that the unprecedented number of women purchasing blonde home hair colour and highlighting kits, and the consumer preference is clear: Every other hair care colour pales in comparison to blonde.

Obviously, we had our work cut out for us. Not only were we developing a brand-new product line, but we were attempting to tackle the unique problems of, literally, the most popular hair colour in the world. Although undeniably beautiful, blonde hair is fraught with unique 'challenges'. To begin with, it is particularly vulnerable to environmental stress. While mineral deposits are Public Enemy No.1 for blonde hair, even seemingly innocuous styling products and conditioners can wreak havoc – dulling and darkening blonde colour to a decidedly unbeautiful hue.

A vast list of minerals (iron, copper, manganese, lead, chromium and nickel) in our water supply, our swimming pools – even in our perspiration – can cause blonde hair to take on green/orange/brown tones. Other minerals, specifically calcium and magnesium salts, create another problem: A dulling film on the surface of the hair. Plus, without the natural lightening effects of the summer sun, that perfect 'beach-blonde' gets duller, darker and loses its healthy glow during harsh winter months.

Our solution was to create an exceedingly gentle shampoo, infused with a special (confidential!) ingredient to remove drabbing, discolouring minerals and films, without stripping the hair of its natural oils. No matter what the season, this shampoo removes unwanted residues and uncovers lighter, brighter sun-kissed blonde.

The shampoo situation resolved, we directed our attention to developing the perfect conditioner for blonde hair. Consulting with Christophe Robin (a Paris-based colourist of renown, who counts the über-blonde Catherine Deneuve among his clients) we discovered that, while colour-treated blonde hair desperately needs supplemental moisturizing, the majority of conditioners tend to darken blonde hair. This problem was also identified by international stylist Sally Hershberger (whose celebrity clients include such Hollywood mega-blondes as Meg Ryan and Michelle Pfeiffer). Sally echoed Christophe's concern – when blondes spend considerable time and money achieving the perfect highlights or single-process colour, the last thing they want is to lose that glistening glow. Back to the lab...

Our chief objective for a 'just-for-blondes' conditioner was to create a product that amplified and intensified blonde, rather than to render it dull, muddy and devoid of highlights. As with the shampoo, we developed conditioners geared to the subtly different needs of two blonde colour ranges: 'platinum to champagne' and 'honey to caramel'. All the conditioning agents used – whether lemon peel extract for lighter shades of blonde or wheat germ oil for darker shades of blonde – were selected to help balance the 'porosity' of blonde hair, which tends to be extra dry, brittle and straw-like (especially if it is colour-treated).

Our special blonde styling products were developed not only to deliver superior styling benefits like volume, shine and manageability, but to accentuate and enhance the beauty of blonde hair. While some traditional styling products dull, darken or even discolour blonde, two of our styling products actually help prevent yellow, brassy tones. Taking a cue from cosmetic companies who use purple-tinted formulas to 'colour-balance' yellow, sallow skin tones, we developed lavender-tinted formulas that neutralise unwanted, off-colour, brassy blonde.

WE BELIEVE, FOR BLONDES THE **ENHANCEMENT** OF THEIR COLOUR IS OF **PARAMOUNT** IMPORTANCE. MAKING THE BLONDE TONES LOOK AS **LIGHT, BRIGHT, NATURAL, HEALTHY** AND **GLOSSY** AS POSSIBLE IS ABSOLUTELY **ESSENTIAL** FOR EVERY NATURAL, HIGHLIGHTED OR COLOUR-TREATED BLONDE. ALL THESE STYLING PRODUCTS **ENHANCE** THE HAIR UNTIL IT IS TIME FOR THE NEXT SHAMPOO... WHICH TAKES US BACK TO THE STARTING POINT FOR THE **ENTIRE** SHEER BLONDE LINE.

bibliography

Adams, David and Wadeson, Jacki	(1998)	*The Art of Hair Colouring*	Macmillan Press Ltd
Basten, Fred E.	(1995)	*Max Factor's Hollywood: Glamour, Movies and Make-Up*	General Publishing Group
Berenson, Bernard	(1952)	*The Italian Painters of the Renaissance*	Phaidon Press
Bloch, Konrad	(1994)	*Blondes in Venetian Paintings and Other Essays*	Yale University Press.
Corson, Richard	(1965)	*Fashions in Hair*	Peter Owen
Fairley, Jo and Stacey, Sarah	(1996)	*The Beauty Bible*	Kyle Cathie
Félix, Sebastien and Baschet, Armand	(1865)	*Les Femmes blondes selon les peintres de l'école de Venise*	Bibliothèque de France
Howell, Georgina	(1975)	*In Vogue*	Penguin Books
Kingsley, Philip	(1979)	*The Complete Hair Book*	Grove Press Inc.
Norman, Barry	(1979)	*The Hollywood Greats*	Hodder and Stoughton
Wall, Florence E.	(1962)	*Principles and Practice of Beauty Culture*	Keystone Publications.
Warner, Marina	(1994)	*From Beast to the Blonde*	Chatto & Windus

picture acknowledgements

All pictures are protected by copyright. All Vogue pictures © The Condé Nast Publications Ltd.

3 top Vogue • 3 centre bottom Robert Erdmann/Vogue • 3 bottom Kim Knott/Vogue • 4 John Swannell/Vogue • 6 Versace Photographic Archive • 8 left Chris Moore • 8 centre Charlotte MacPherson • 8 right Vogue • 9 Venus and Adonis, 1580 by Veronese (Paolo Caliari) (1528–88), Prado, Madrid/Index/Bridgeman Art Library, London/New York • 9 left Martine Sitbon/Vogue • 9 centre Vogue • 9 right Vogue • 11 David by Michelangelo Buonarroti (1475–1564), 1501–04 (marble), Galleria dell'Accademia, Florence/Bridgeman Art Library, London/New York • 13 The Birth of Venus, c. 1485 (tempera on canvas) by Sandro Botticelli (1444/5–1510), Galleria degli Uffizi, Florence/Bridgeman Art Library, London/New York • 14 Marriage of the Virgin, detail showing one of the Virgin's companions, 1500–1504 (oil on canvas) by Pietro Perugino (c. 1445–1523), Musée des Beaux Arts, Caen/Peter Willi/Bridgeman Art Library, London/New York • 17 Max Factor & Co. • 18–20 Macmillan • 22/23 Sean Cunningham/Vogue • 24 May I Climb Up? by Ernest Howard Shepard (1879–1976), Chris Beetles Ltd., London, UK/Bridgeman Art Library, London/New York • 25 Vogue • 26 Vogue • 27 Tiger Lily, from Through the Looking Glass (litho), Private Collection/Bridgeman Art Library, London/New York • 28 Little Mermaid, by Hans Christian Anderson, Private Collection/Bridgeman Art Library, London/New York • 31 Vogue • 33 Rex Features • 34 Vogue • 37 Kobal • 39 The Ronald Grant Archive • 40 Kobal • 42 The Ronald Grant Archive • 43 Kobal • 44 Kobal • 46 The Ronald Grant Archive • 47 Kobal • 49 Kobal • 50 left Kobal • 50 right Universal/Kobal • 51 left MGM/Kobal • 51 right Universal Pictures • 53 EON Productions • 54 top EON/United Artists/Kobal • 54 centre left Kobal • 54 centre right EON/United Artists/Kobal • 54 bottom Kobal • 55 top EON/United Artists/Kobal • 55 centre Rex Features 55 bottom Rex Features • 57 Rex Features • 58 top Compton-Tekli/Royal/Kobal • 58 bottom David Bailey/Vogue • 59 Brian Duffy/Vogue • 60 Barry Lategan • 62 Kobal • 63 Yoram Kahana/Kredenser/Shooting Star • 64 Firooz Zahedi/Janet Botaish Group • 66 Mario Testino/Art Partner • 67 top Rex Features • 67 bottom Joshua Jordon/Jed Root, Inc. • 68 Alpha • 70 Annie Liebowitz • 71 Andrew Eccles/Outline/Katz Pictures • 73 Rex Features • 75 Rex Features • 76 Kobal • 77 top The Ronald Grant Archive • 77 bottom Kobal • 78 Rex Features • 79 Michel Haddi/Vogue • 80–83 Allsport • 84 Albert Watson/Vogue • 85 top Polygram/Pictorial Press • 85 centre top Kobal • 85 centre bottom Kobal • 85 bottom Rex Features • 87 Rex Features • 89 Herb Ritts/Visage/Colorific • 90 Nick Knight/The Face • 92 Rex Features • 93 Bowstir Limited • 94–95 Michel Haddi/Vogue • 96 top King Collection/Retna Pictures • 96 bottom Rex Features • 97 GQ/Peter Robathan • 98–99 Rex Features • 99 top right Diego Uchitel/Katz Pictures • 101 Regan Cameron • 102 The Ronald Grant Archive • 103 Marilyn (silk screen) by Andy Warhol (1930–87), Phillips, The International Fine Art Auctioneers/Bridgeman Art Library, London/New York, © The Andy Warhol Foundation for the Visual Arts Inc/ARS, NY and DACS, London 1999 • 104 Hulton Getty Images • 105 Cinergi/Kobal • 106 Patrick Demarchelier/Vogue • 107 Barry Lategan • 109 Steven Meisel/A+C Anthology • 110–111 Yves Saint Laurent Beauté • 113 The Ronald Grant Archive • 114/5 Kevyn Aucoin • 116 The Ronald Grant Archive • 117 top left Kobal • 117 top right Robert Erdmann/Icon International • 117 centre and bottom left Magnum • 117 bottom right Kobal • 118–119 Vogue • 120 Chris Moore • 121 Chris Moore • 122 left Vogue • 122 centre Charlotte MacPherson • 122 top right Sean Cunningham/Vogue • 122 bottom right Vogue • 123 left Charlotte MacPherson • 123 centre top Charlotte MacPherson • 123 centre bottom Vogue • 123 right Charlotte MacPherson • 124 Steven Meisel/A+C Anthology • 125-126 Vogue • 127 far left Vogue • 127 left Charlotte MacPherson • 127 centre Sean Cunningham/Vogue • 127 right Charlotte MacPherson • 127 far right Vogue • 128–129 Vogue • 131 L'Oréal • 132-133 Rex Features • 134 Victor Skrebneski/Estée Lauder Cosmetics • 135 Mark Bourdillon/Scope Features • 136 Richard Avedon • 137 Paolo Roversi/Jil Sander AG • 138 Kobal • 139 top Kobal • 139 bottom Rex Features • 142 Clairol Incorporated.

Front cover photograph: Robert Fairer Photography; back cover photographs: Vogue, Rex Features, Kobal

The poem For Anne Gregory by W.B. Yeats on page 32 is reproduced by kind permission of AP Watt Ltd on behalf of Michael Yeats.

While every effort has been made to trace all copyright holders this has proved difficult in some cases. The publishers ask any copyright holders not mentioned to accept their apologies and to contact the publishers so that a proper credit can be made when the book reprints.